Ecological Design

teNeues

Imprint

Produced by fusion publishing GmbH, Stuttgart . Los Angeles www.fusion-publishing.com

Editorial team:
Manuela Roth (Editor + Layout)
Nicolas Uphaus (Texts)
Jan Hausberg, Anke Scholz (Prepress + Imaging)
Alphagriese Fachübersetzungen, Düsseldorf (Translations)

Photos (pages): Steffen Jänicke (13–15), Achim Hehn (17–19), Design Mobel (21–23, Cover), Thomas Ibsen (25–27, back cover), Michaele Simmering (10, 29–30, 124), Erik Blinderman (31, 123, 125), drawings Johannes Pauwen (28, 122), David Trubridge (32–33), molo (4, 9, 35–37, 117–119), Artecnica (8, 38–41, 106–109), Mels Van Zutphen (43–45), Robert Hakalski (47–49, 98–101, back cover), Courtesy of Studiomold (50–51), Courtesy mixko and mixko.net (52–53), David Steets (54–55, 120–121), Civil Twilight (56–59), Chrissy Angliker (60–63), bartsch design (5, 64–67), Parans (69–71), Kari Sivonen (73–77), bambu LLC (78–81), Florian Groehn (82–85), Resolution: 4 Architecture (86–89), David Burrows (90–93), Daniel Lane (94–97), Geoff Sumner (103–105), MUJI (110–111, 130–131), Courtesy of Vessel (112–115), Lucy Jane Batchelor (127–129), Jared Rasmussen (133–135), philips speech processing, GP designpartners (136–137), Whitehall photographie, Hamburg, M. Paul Schimweg (138–139), Tim Wigmore Design (141–143), 2007 Hewlett-Packard Development Company, L.P. (144–145), Courtesy of Steelcase (6, 146–149, 156–157), fuseproject (150–153), Courtesy of Goods (154–155), John Aitchison (159–161), Alan Froberg (162–164), Joe Wigdahl (165), Courtesy of Illu Stration (11, 166–167), Revolve (168–171, back cover), Courtesy Rcyclia (173–175), Josh Jakus (176), Aya Brackett (177–179), Courtesy Wheels-on-Fire (180–183), Michel Zumbrunn (7, 184–187, back cover), Herman van Ommen (188–191), BMW AG (192–195), Stephane Foulon (3, 196–199), Feetz (201–203), Nico (204–205), Barry Hathaway (206–207), Roland Kaufmann (209), Tom Lingnau, Frank Schumacher (210–211), Tesla Motors (212–217), Alexandre Verdier (218–221, back cover), Frank Brandwijk (222–223)

Published by teNeues Publishing Group

teNeues Verlag GmbH + Co. KG
Am Selder 37
47906 Kempen, Germany
Tel.: 0049-(0)2152-916-0
Fax: 0049-(0)2152-916-111
E-mail: books@teneues.de

teNeues Publishing Company
16 West 22nd Street
New York, NY 10010, USA
Tel.: 001-212-627-9090
Fax: 001-212-627-9511

teNeues Publishing UK Ltd.
P.O. Box 402
West Byfleet
KT14 7ZF, Great Britain
Tel.: 0044-1932-403509
Fax: 0044-1932-403514

teNeues France S.A.R.L.
93, rue Bannier
45000 Orléans, France
Tel.: 0033-2-38541071
Fax: 0033-2-38625340

Press department: arehn@teneues.de
Tel.: 0049-(0)2152-916-202

www.teneues.com

ISBN: 978-3-8327-9229-9

© 2008 teNeues Verlag GmbH + Co. KG, Kempen

Printed in Italy

Bibliographic information published by Die Deutsche Bibliothek.
Die Deutsche Bibliothek lists this publication in the Deutsche Nationalbibliografie; detailed bibliographic data is available in the Internet at http://dnb.ddb.de.

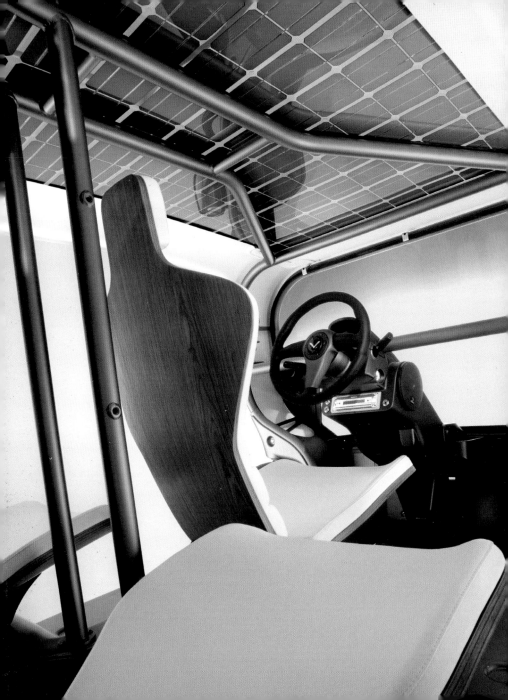

Introduction 6

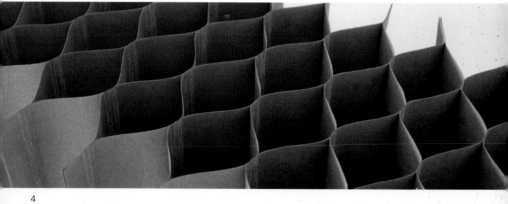

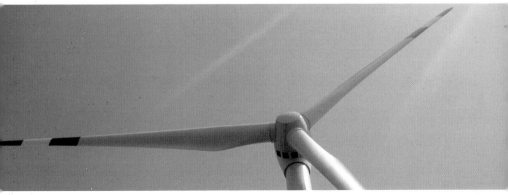

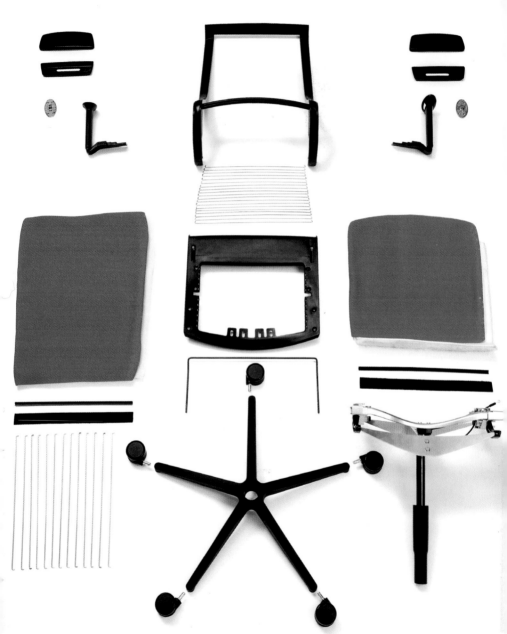

Introduction

What is ecological design? What distinguishes a sustainable product? Product quality is determined by the interplay of various factors. Many consumers—and even designers—may not be aware of them.

The selection of materials already sets the course: Which basic materials are employed and under what conditions are these acquired? Are renewable raw materials used? Are these recycling materials or can they be recycled? What are the production circumstances? Is it possible to produce it in a way that saves energy and water? Is the emissions level as low as possible during production and is the product without emissions when used? What type of transportation and packaging is used? The packaging involved should be as minimal as possible, and the transportation routes should not be unnecessarily long. When a design saves materials, it not only makes the product less expensive but also uses fewer resources in manufacturing and logistics. What ultimately happens if a product is defective or its useful life is over? A good product can simply be repaired or easily disassembled at the end of its life and recycled as completely as possible.

When people buy sustainably manufactured products, they get more than just a good conscience, but also do something good for themselves: Long-lasting enjoyment of a good product and use of it without health risks are qualities that should not be underestimated.

Ecological products are in demand not only because of the current debate on sustainability and climate change—many companies have already recognized that these important criteria are necessary in order for products to be seen as high quality, which determines the demand for them.

Good designers have the task of translating the demand for ecological products into high-quality items. This book gathers outstanding, innovative, and sometimes unique examples, dividing them into chapters on Furniture, Lighting and Energy, Household, Kids, Office, Accessories, and Mobility.

Nicolas Uphaus

Einleitung

Was ist ökologisches Design, was zeichnet ein Produkt als nachhaltig aus? Das Zusammenspiel etlicher Faktoren, die vielen Konsumenten – und sogar manchen Designern – nicht bewusst sind, bestimmt die Produktqualität.

Schon die Materialauswahl stellt die Weichen: Welche Ausgangsmaterialien werden verwendet, und unter welchen Bedingungen werden diese gewonnen? Kommen nachwachsende Rohstoffe zum Einsatz? Handelt es sich um Recyclingmaterialen oder können sie recycelt werden?

Unter welchen Umständen wird produziert? Ist eine energie- und wassersparende Produktion möglich? Ist die Herstellung emmissionsarm und das Produkt im Gebrauch emmissionsfrei?

Wie sieht es mit Transport und Verpackung aus? Der Verpackungsaufwand sollte so gering wie möglich gehalten werden, Transportwege nicht unnötig lang sein. Eine materialsparende Gestaltung macht ein Produkt nicht nur günstiger, es werden auch weniger Ressourcen bei der Herstellung und Logistik verbraucht.

Was passiert schließlich, wenn ein Produkt defekt oder seine Lebensdauer vorüber ist? Ein gutes Produkt lässt sich einfach reparieren oder an dessen Lebensende leicht demontieren und möglichst vollständig recyceln.

Der Käufer nachhaltig hergestellter Produkte erhält nicht nur ein gutes Gewissen inklusive, sondern er tut sich auch etwas Gutes: Lange Freude am guten Produkt und eine Nutzung ohne Gesundheitsbelastung sind nicht zu unterschätzende Qualitäten.

Nicht nur durch die aktuelle Debatte um Nachhaltigkeit und Klimawandel sind ökologische Produkte gefragt – längst haben viele Unternehmen erkannt, dass ohne diese wichtigen Kriterien bald kaum ein Produkt mehr als qualitätvoll wahrgenommen und entsprechend nachgefragt wird.

Die Aufgabe guten Designs besteht darin, diese Nachfrage nach ökologischen Erzeugnissen in Form hochwertiger Produkte umzusetzen. Herausragende, innovative und manchmal originelle Beispiele versammelt dieser Band, der in die Kapitel Möbel, Beleuchtung und Energie, Haushalt, Kinder, Büro, Accessoires und Mobilität unterteilt ist.

Nicolas Uphaus

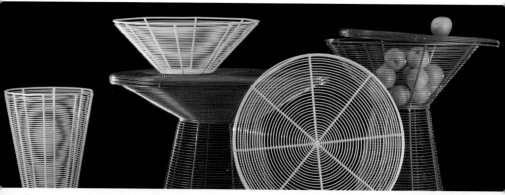

Introduction

Qu'est-ce que le design écologique ? Qu'est-ce qui caractérise un produit durable ? La qualité d'un produit est déterminée par l'interaction entre plusieurs facteurs, inconnus de la plupart des consommateurs – et même de certains designers.

Le choix des matériaux indique la marche à suivre : quels matériaux de base employer et sous quelles conditions les acquérir ? Doit-on utiliser des matériaux renouvelables ? Des matériaux recyclables ou recyclés ? Dans quelles conditions fabriquer le produit ? Est-il possible de le produire en économisant de l'eau et de l'énergie ? Quels types de transports et d'emballage utiliser ? L'emballage devrait être réduit au maximum, et les circuits de transport pas inutilement longs. Un design économe en matériaux ne rend pas seulement le produit moins cher mais requiert également moins de ressources pour la fabrication et la logistique.

Que se passe-t-il si un produit est défectueux ou si sa durée de vie est terminée ? Un bon produit peut être réparé simplement et, quand il arrive à la fin de sa vie, facilement désassemblé et recyclé aussi complètement que possible.

Les acheteurs de produits durables ne gagnent pas seulement un peu de bonne conscience au change, mais se font aussi du bien à eux-mêmes, car ils profiteront pendant longtemps d'un bon produit, dont l'utilisation est sans risque pour la santé : deux qualités qui ne doivent pas être sous-estimées.

Il y a une forte demande pour les produits écologiques, et ce pas seulement à cause des débats actuels sur le développement durable et le changement climatique : de nombreuses entreprises ont déjà reconnu que sans ces critères essentiels, quasiment aucun produit ne peut être considéré de très bonne qualité, et donc être recherché.

Un bon design doit convertir cette demande pour les produits écologiques en des articles d'excellente qualité. Cet ouvrage rassemble des exemples fabuleux, innovants et parfois uniques, répartis dans des chapitres intitulés Mobilier, Eclairage et Energie, Maison, Enfants, Bureau, Accessoires et Mobilité.

Nicolas Uphaus

Introducción

¿Qué es el diseño ecológico? ¿Qué caracteriza a un producto sostenible? La conjugación de diversos factores, desconocidos para la mayoría de consumidores —y hasta para algunos diseñadores—, determina la calidad del producto.

La misma elección de los materiales marca el camino a seguir: ¿Qué materias se emplean?, ¿en qué condiciones se obtienen las mismas?, ¿se utilizan materias primas renovables?, ¿se trata de materiales reciclables o que permitan su reciclaje?, ¿es factible su producción con un consumo reducido de energía y agua?, ¿en qué condiciones se lleva a cabo la producción?, su elaboración, ¿es baja en emisiones?, y su uso, ¿genera algún tipo de emisión?, ¿cómo se embala y se transporta? El empaquetado habrá de ser el mínimo posible, al igual que el transporte, para evitar largos trayectos innecesarios. Una concepción con escasos materiales no solo consigue que un producto sea más económico, sino que, además, en su elaboración y en la logística aplicada se emplean menos recursos.

¿Qué sucede cuando un producto acaba saliendo defectuoso o llega al final de su vida útil? Si es de buena calidad, se podrá reparar de forma sencilla, y cuando deje de funcionar, se podrá desmontar con facilidad y, a ser posible, reciclar en su totalidad.

Al comprador de productos sostenibles no solo le queda una buena conciencia, sino que también se hace un gran favor, pues disfrutará durante mucho tiempo de un objeto de calidad, cuyo uso no le perjudicará la salud; ambas cualidades no son nada desdeñables.

Los productos ecológicos están en boga no solo por los debates actuales sobre sostenibilidad y cambio climático. Son muchas las empresas que han sabido ver desde hace tiempo que si no se aplican estos criterios tan importantes, muy pronto apenas habrá productos de verdadera calidad y, por consiguiente, tampoco habrá demanda.

Convertir los productos ecológicos en objetos de gran valor es el objeto de un buen diseño. En este volumen se han recogido excelentes ejemplos, innovadores y muchas veces de lo más originales, y se han organizado en los capítulos siguientes: mobiliario, iluminación y energía, menaje, niños, oficina, accesorios y movilidad.

Nicolas Uphaus

Introduzione

Che cos'è il design ecologico e cosa definisce un prodotto durevole? La qualità del prodotto viene stabilita dall'interazione di diversi fattori, dei quali molti consumatori – e a volte anche alcuni designer – non sono consapevoli.

Già la scelta dei materiali prepara il terreno: Quali materiali iniziali si utilizzano e a quali condizioni sono stati ottenuti? Vengono utilizzate materie prime che ricrescono? Si tratta di materiali riciclati o che possono essere riciclati? A quali condizioni si produce? E' possibile una produzione a risparmio energetico e che economizzi sull'acqua? La produzione è a bassa emissione e il prodotto viene utilizzato a emissione zero?

Come viene svolto il trasporto e il confezionamento? L'imballaggio dovrebbe essere il più ridotto possibile, i percorsi per il trasporto non devono essere inutilmente lunghi. Una creazione che risparmia sul materiale rende il prodotto non solo più conveniente, ma fa pure in modo che vengano utilizzate meno risorse durante la produzione e la logistica.

Che succede infine se un prodotto è difettoso o se la sua durata è giunta al termine? Un buon prodotto si può riparare facilmente o alla fine del suo ciclo vitale può essere facilmente demolito e possibilmente riciclato completamente.

L'acquirente di prodotti durevoli non solo riceve incluso nel pacchetto una buona coscienza, ma fa del bene anche a se stesso: il piacere duraturo di un buon prodotto e l'utilizzo senza danneggiare la salute non sono qualità da sottovalutare.

I prodotti ecologici sono richiesti non soltanto a causa di dibattiti attuali sulla durevolezza e il cambiamento climatico – da tempo molte imprese hanno riconosciuto che senza questi importanti criteri ben presto non verrà più considerato e di conseguenza richiesto alcun prodotto che non sia di alta qualità.

La trasformazione della richiesta di prodotti ecologici in prodotti finali pregiati è compito del buon design. Questo volume raccoglie esempi straordinari, innovativi e a volte originali, suddivisi nei capitoli Mobili, Illuminazione ed Energia, Casalinghi, Bambini, Ufficio, Accessori e Mobilità.

Nicolas Uphaus

books

Designer: Studio Aisslinger
Manufacturer: Prototype, www.aisslinger.de

Books as raw material? Discarded large-format books and a cross-shaped metal connector are turned into a distinctive object that can be expanded as desired. It can serve as a wall or room divider. Or as a bookshelf that virtually grows out of itself.

Bücher als Rohstoff? Aus ausrangierten großformatigen Büchern und einem kreuzförmigen Metallverbinder entsteht ein unverwechselbares und beliebig erweiterbares Objekt, das als Wand oder Raumteiler dienen kann, oder als Bücherregal quasi aus sich selbst heraus wächst.

Des livres comme matière première ? Des livres en grand format au rebut et un connecteur métallique cruciforme sont transformés en un objet spécial qui peut être agrandi à souhait. Il peut servir de mur ou de cloison, ou bien encore comme une bibliothèque qui sortirait littéralement d'elle-même.

¿Libros como materia prima? Libros desechados de gran formato y una cruceta de metal que sirve de soporte conforman un inconfundible objeto que se amplía a voluntad y que puede funcionar de tabique o mampara. O también de librería que va creciendo casi de forma endógena.

Usare libri come materia prima? Da libri scartati di grande formato e un collegamento metallico a croce viene creato un oggetto inconfondibile e variabile a piacere in misura, che può servire come parete o divisorio per ambienti. O, come va da sé, si può usarlo come scaffale per libri.

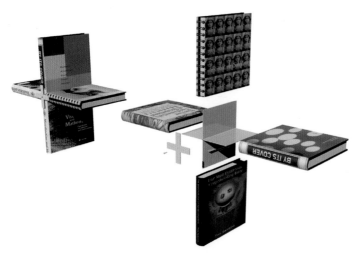

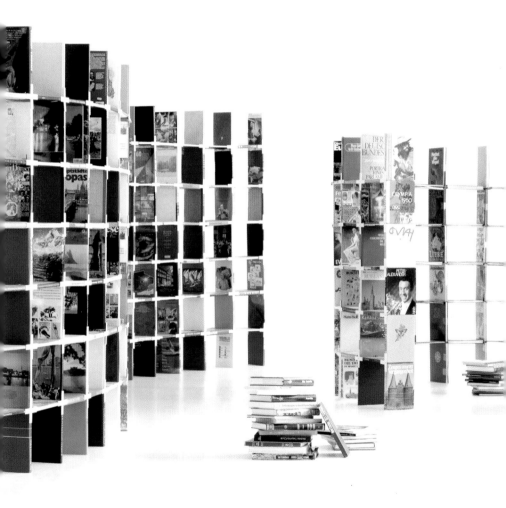

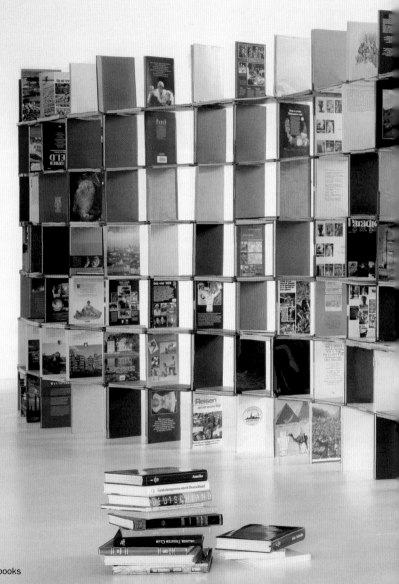

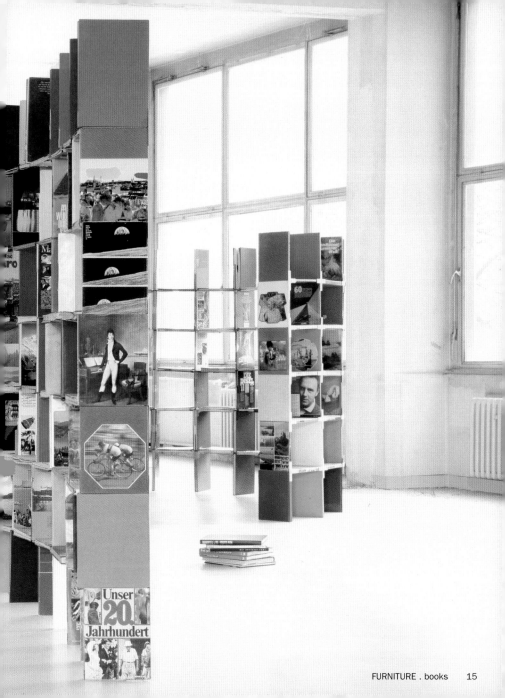

bordbar

Designer: Stephan Boltz
Manufacturer: Stephan Boltz, www.bordbar.de

These pieces of furniture have already flown many miles around the world as airplane trolleys. But now they have a new purpose. Individually printed and equipped, the robust furniture can be used flexibly. Whether in the office, kitchen, or living room—the seasoned travelers provide good services everywhere.

Diese Möbelstücke sind als Flugzeugtrolleys schon viel um die Welt geflogen, nun erhalten sie eine neue Bestimmung. Individuell bedruckt und ausgestattet sind die robusten Möbel flexibel einsetzbar. Ob in Büro, Küche oder Wohnzimmer – die Vielgereisten leisten überall gute Dienste.

Ces meubles ont déjà parcouru des kilomètres autour du monde en tant que chariots d'avion, et maintenant ils ont une nouvelle utilisation. Imprimés et équipés individuellement, ces meubles robustes ont divers usages. Au bureau, dans la cuisine ou au salon, ces voyageurs patentés servent partout.

Estos muebles han viajado mucho por el mundo en forma de carros de servicio en los aviones. Ahora tienen otro fin. Con estampado y equipamiento individualizados, estos robustos muebles permiten los más diversos usos. En la oficina, la cocina o la sala de estar, siempre cumplirán con su función.

Questi mobili, che hanno già girato molto il mondo come trolley per l'aereo, ora ricevono una nuova designazione. Con stampe e allestimenti individuali, i mobili robusti sono flessibili da usare. In ufficio, nella cucina o nel salone – questi viaggiatori nati prestano un buon servizio, ovunque.

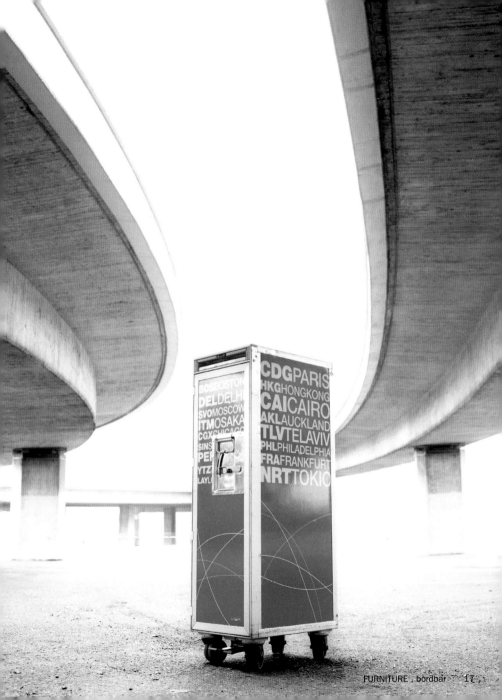

The cart is labeled with the following city codes and names:

CDG PARIS
HKG HONGKONG
CAI CAIRO
AKL AUCKLAND
TLV TELAVIV
PHL PHILADELPHIA
FRA FRANKFURT
NRT TOKIO

BOS BOSTON
DEL DELHI
SVO MOSCOW
ITM OSAKA
CGX CHICAGO
SIN S...
PE...
YTZ...
LAY L...

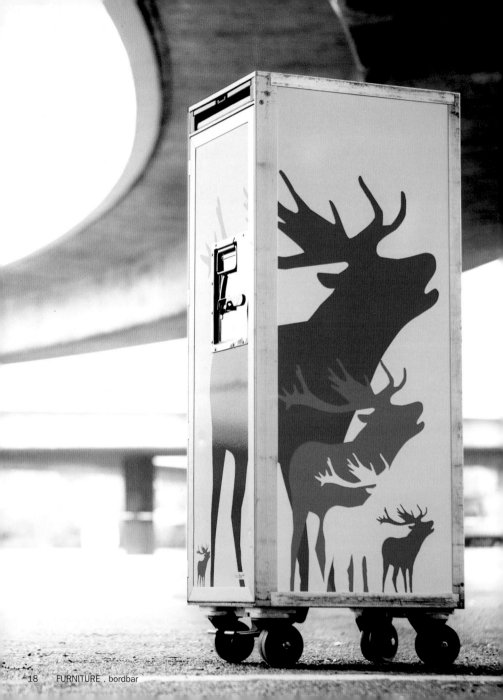

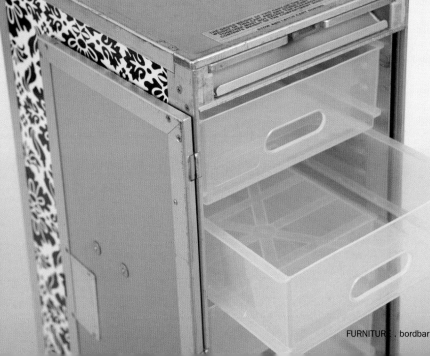

Float

Designer: David Trubridge
Manufacturer: Design Mobel, www.designmobel.com

The characteristics of sleep, not the issue of the bed itself, were the main focus for the designer in creating this special place to sleep. This large cradle of sustainably cultivated New Zealand totara wood is shielding, protective, and romantic.

Nicht die Frage nach einem Bett, sondern nach Charakteristiken des Schlafes standen für den Designer beim Entwurf dieser speziellen Schlafstatt im Vordergrund. Behütend, beschützend und romantisch soll diese große Wiege aus nachhaltig angebautem neuseeländischem Totara-Holz sein.

Le souci principal des designers n'étaient pas le problème du lit mais les caractéristiques du sommeil lors de la création de ce lieu particulier pour dormir. Ce grand berceau de bois de totara néozélandais cultivé de manière durable est protecteur et romantique.

El diseñador de este lecho tan especial se planteó a la hora de concebirlo cuestiones relaciona-das más bien con las características del sueño y no tanto con la concepción de una cama. Protec-tora y romántica resulta esta cuna gigante de madera neozelandesa de totara de plantaciones sostenibles.

Nel progettare questo giaciglio speciale, il designer non si è posto il problema del letto, ma ha messo in primo piano le caratteristiche del sonno. Questa grande culla, **fatta** di legno durevole di Totara della Nuova Zelanda, ha lo scopo di essere protettiva e romantica.

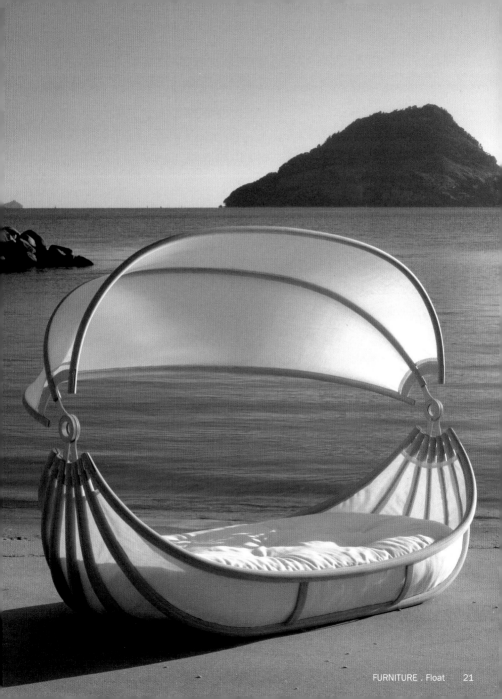

FURNITURE . Float 21

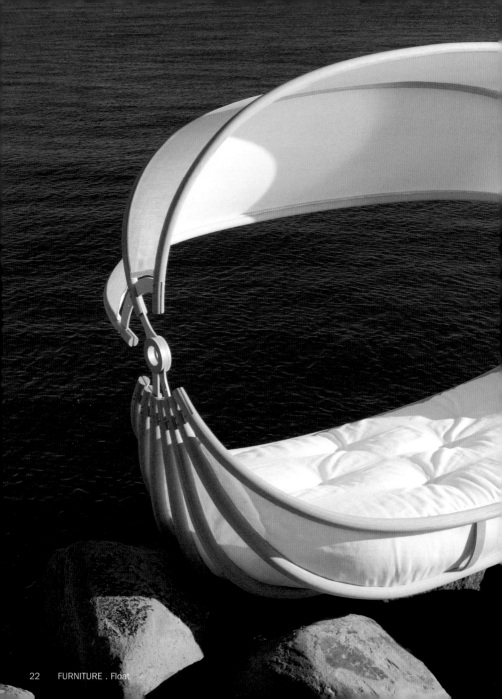

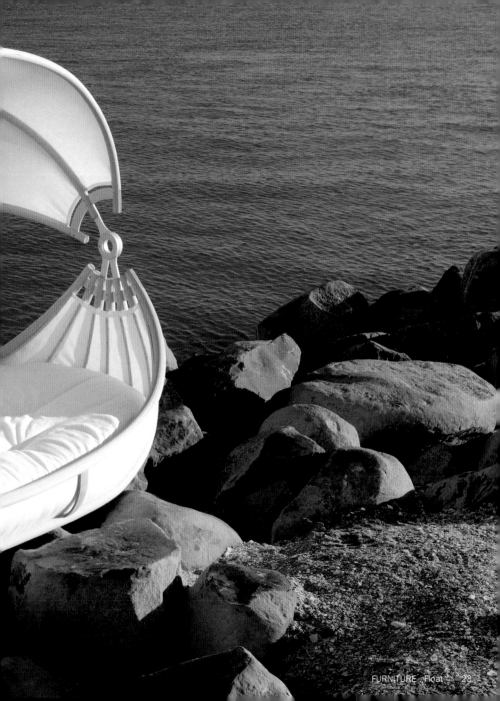

Gubi Chair II

Designer: KOMPLOT DESIGN
Manufacturer: Gubi, www.gubi.dk

This recyclable chair consists of a steel (tubular) frame moulded in between two mats of PET felt in a single process. PET felt, partially manufactured from used plastic bottles, has been previously employed in the automotive industry, now proves its flexibility and robustness in the furniture sector.

Dieser wiederverwertbare Stuhl besteht aus einem Stahlrohrrahmen, der in einem einzigen Produktionsprozess zwischen zwei PET-Matten eingegossen ist. Bisher in der Automobilindustrie verwendet, beweist der zum Teil aus recycelten Plastikflaschen gewonnene PET-Filz nun seine Flexibilität und Robustheit im Möbelbereich.

Cette chaise recyclable consiste en un cadre (tubulaire) d'acier moulé entre deux couches de feutre PET en un seul processus. Le feutre PET, fabriqué en partie avec des bouteilles en plastique usagées, était précédemment utilisé dans l'industrie automobile et prouve à présent sa flexibilité et sa robustesse dans le secteur du mobilier.

Esta silla reciclable se compone de una estructura de acero (tubular) moldeada entre dos piezas de fieltro de PET en un solo procesado. Este fieltro, procedente en parte de botellas recicladas, se empleó con anterioridad en la industria automotriz; hoy demuestra su flexibilidad y robustez en el sector del mobiliario.

Questa sedia riciclabile è composta da una cornice in acciaio (tubolare) modellata in un singolo processo tra due reti di cartonfeltro in PET. Il cartonfeltro in PET, parzialmente prodotto da bottiglie di plastica usate, è stato precedentemente impiegato nell'industria automobilistica, ed ora dimostra la sua flessibilità e la robustezza nel settore dell'arredamento.

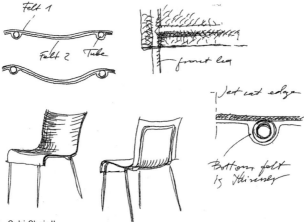

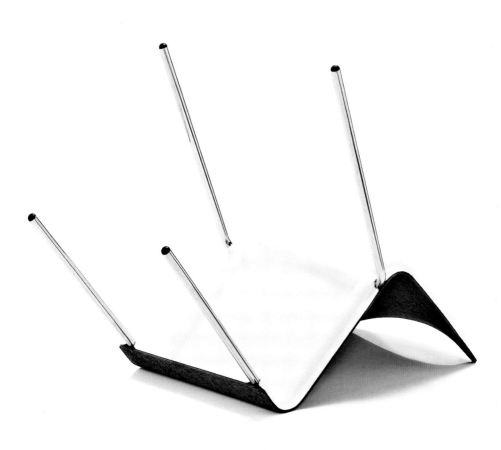

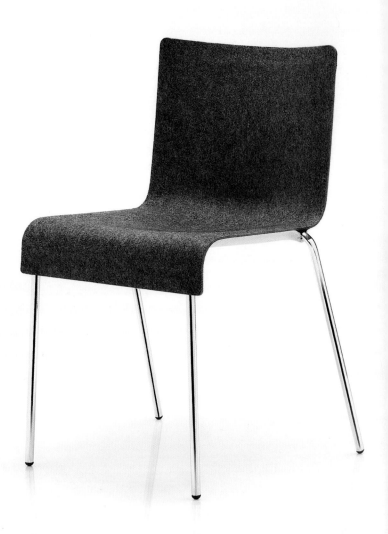

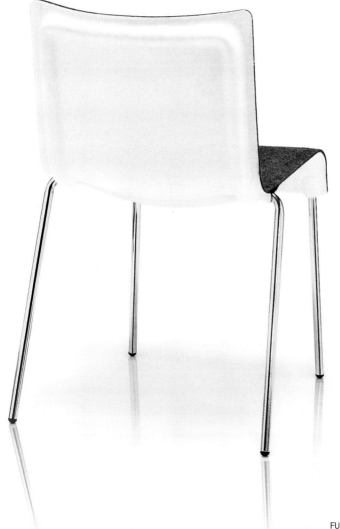

Isometric Chair

Designer: Kalon Studios
Manufacturer: Kalon Studios, www.kalonstudios.com

This chair is made of bamboo only. The fast-growing raw material is used in a laminated form and is subjected to a highly precise CNC manufacturing process. In addition, the glue for the production is non-toxic and the wax for the surface treatment is natural and also non-toxic.

Nur aus Bambus ist dieser Stuhl gefertigt. Der schnell nachwachsende Rohstoff kommt schicht-verleimt zum Einsatz und wird in hochpräziser CNC-Fertigung verarbeitet. Der Leim für die Herstellung ist ungiftig und das Wachs für die Oberflächenbehandlung ist zudem natürlich.

Cette chaise est faite seulement à partir de bambou. Cette matière première à la croissance rapide est utilisée sous forme de contreplaqué et soumise à un procédé de fabrication CNC extrêmement précis. De plus, la colle utilisée est non-toxique, tout comme la cire naturelle qui sert au traitement de surface.

Esta silla se elabora únicamente con bambú. Este material, de crecimiento rápido, se aplica por capas encoladas y se le da un acabado CNC de alta precisión. La cola utilizada en la fabricación no es tóxica y el pulimento aplicado a la superficie es además de origen natural.

Questa sedia è fatta solo di bambù. La materia prima, che ha una ricrescita veloce, viene incollata a strati e viene elaborata con una produzione di massima precisione CNC. La colla per la produzione non è tossica e la cera per il trattamento della superficie è naturale e anch'essa non tossica.

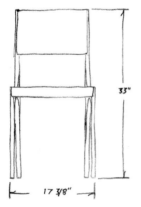
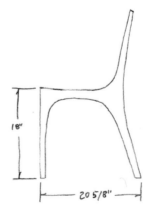

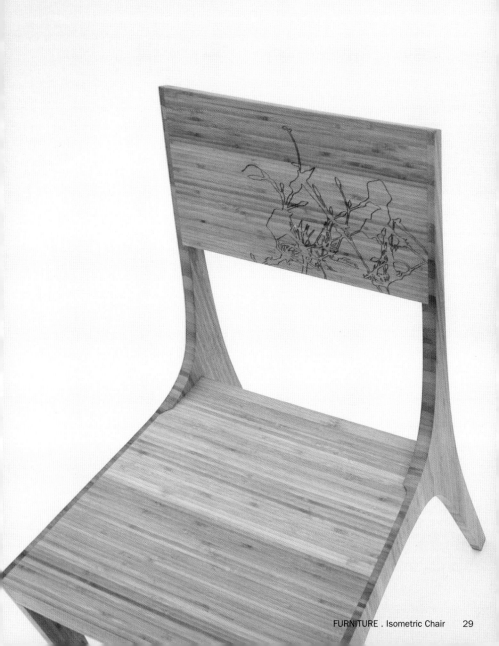

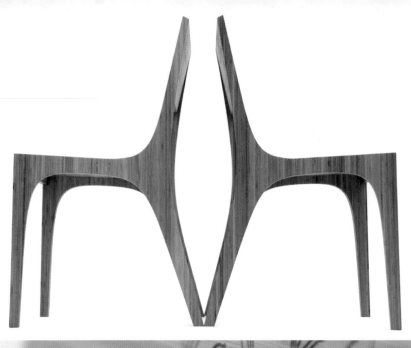

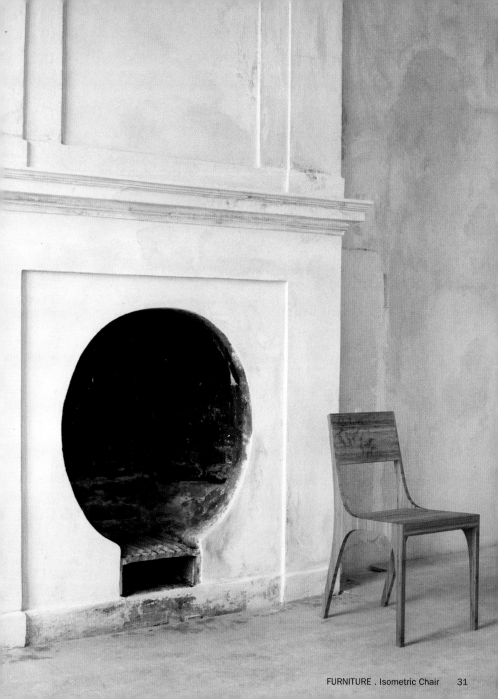

New Sling

Designer: David Trubridge
Manufacturer: David Trubridge Ltd., www.davidtrubridge.com

This beautiful sun lounger, which is also stable and durable, blends several earlier works by the designer. Made from sustainably cultivated wood, this piece of furniture also displays unmistakable maritime influences in its styling.

Diese wunderschöne und gleichzeitig stabile und langlebige Liege ist eine Verschmelzung aus mehreren früheren Arbeiten des Designers. Gefertigt aus nachhaltig angebautem Holz, zeigt das Möbelstück zudem unverkennbar maritime Einflüsse in der Formgebung.

Cette belle chaise longue, qui est aussi stable et durable, mélange plusieurs travaux antérieurs du designer. Fabriqué à partir de bois issu de l'agriculture raisonnée, ce meuble affiche également un style aux influences maritimes manifestes.

Esta maravillosa tumbona, muy estable y duradera, es el resultado de la conjugación de trabajos previos del diseñador. Elaborada con madera de plantaciones sostenibles, esta pieza de mobiliario muestra inequívocas influencias marineras en su línea.

Questa sdraia magnifica e al contempo stabile e duratura, è l'unione di diversi precedenti lavori del designer. Fatta di legno coltivato in modo durevole, questo mobilio esibisce inoltre nella modellatura degli inconfondibili influssi marittimi.

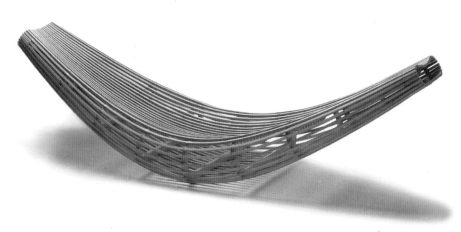

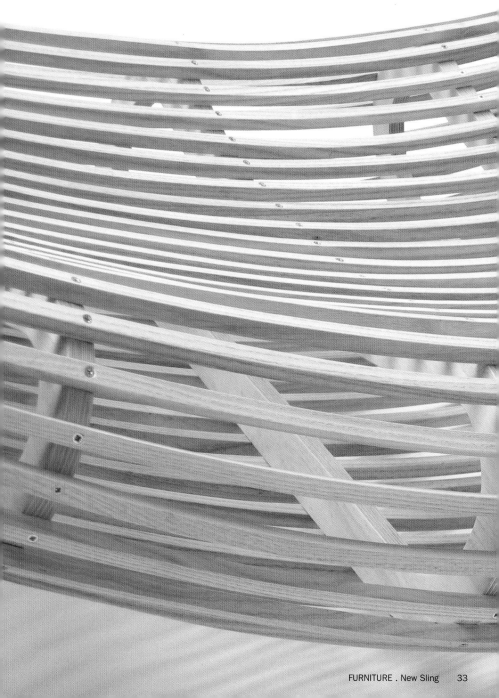

Softseating and Softwall

Designer: Todd MacAllen and Stephanie Forsythe of molo
Manufacturer: molo, www.molodesign.com

Made of paper or textile, stabilized by a honeycomb structure and connected with magnets, the abstract softseating elements can be changed into organic seating sculptures. The softwall elements, which can be used as room dividers, are based on the same principle.

Hergestellt aus Papier oder Textil, stabilisiert durch eine Wabenstruktur und mit Magneten verbunden, lassen sich die abstrakten Softseating-Elemente in organische Sitzskulpturen verwandeln. Auf demselben Prinzip basieren die Softwall-Elemente, die als Raumteiler zum Einsatz kommen.

Fabriqués à base de papier ou de textile, stabilisés par une structure en alvéoles et reliés avec des aimants, les éléments softseating abstraits peuvent être transformés en sculptures d'assise organiques. Les éléments softwall, qui peuvent servir de cloisons, sont basés sur le même principe.

Elaborados a base de papel o de textiles, estabilizados con una estructura en panal y unidos mediante imanes, los abstractos asientos de Softseating se transforman en esculturas orgánicas. Los elementos de la línea Softwall se basan en los mismos principios y se utilizan como mamparas.

Prodotti da carte o stoffa, stabilizzati grazie a una struttura a nido d'ape e collegati con magneti, gli elementi astratti softseating si possono trasformare in sculture organiche per sedersi. Sullo stesso principio si basano gli elementi softwall, che vengono utilizzati per suddividere gli ambienti.

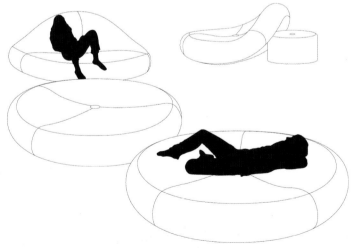

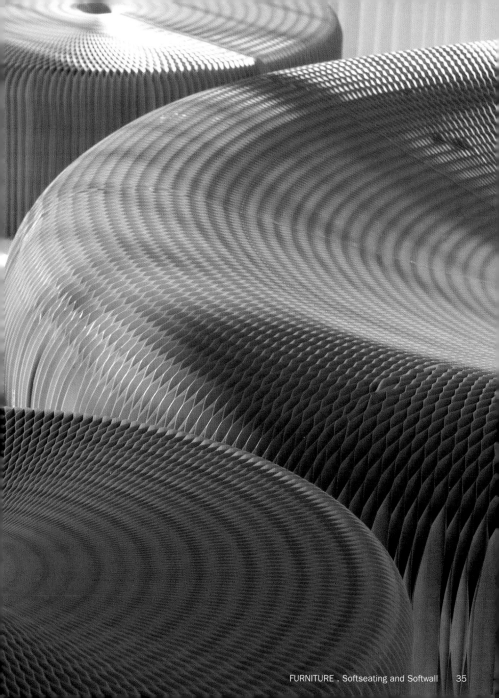

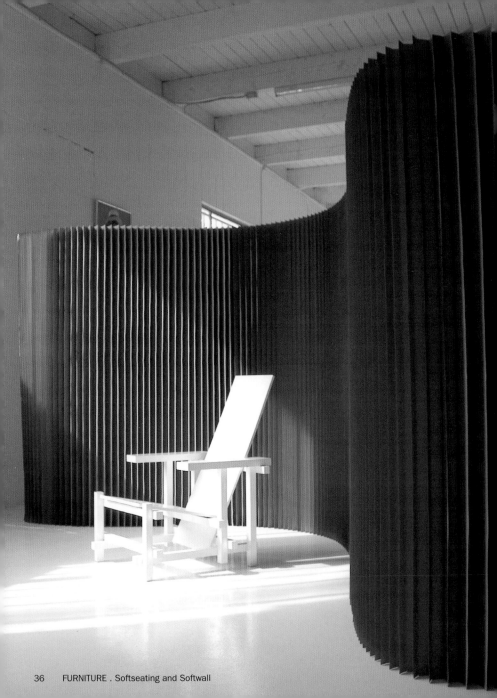

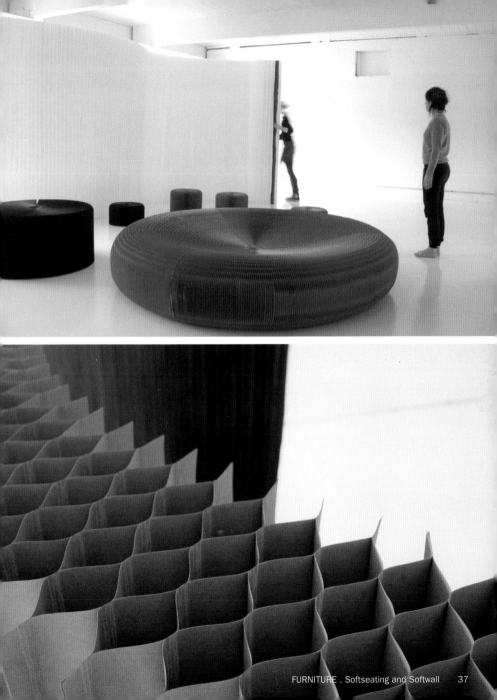

taTu

Designer: Stephen Burks
Manufacturer: Artecnica, www.artecnicainc.com

Do you need a side table, tray, bowl, and basket—or would you prefer a stool, bowl, tray, and wastepaper basket? The pieces of furniture made from powder-coated metal wire in Zimbabwe of the taTu series are many things in one—and even weatherproof on top of it.

Benötigen Sie Beistelltisch, Tablett, Schale und Korb – oder doch lieber Hocker, Schale, Tablett und Abfalleimer? Die in Simbabwe gefertigten Möbelstücke der Serie taTu aus pulverbeschichtetem Metalldraht sind vieles in einem – und sogar noch wetterfest.

Avez-vous besoin d'une console, d'un plateau, d'un bol et d'un panier – ou d'un tabouret, d'un bol, d'un plateau et d'une corbeille à papier ? Ces meubles de la collection taTu fabriqués au Zimbabwe en fil métallique avec revêtement poudre sont multifonctions, et résistent même aux intempéries.

¿Necesita una mesa, una bandeja, una fuente o una cesta? ¿O un taburete que sea fuente, bandeja y papelera? Los objetos de la serie taTu, hechos en Zimbabue con alambre con baño de polvo, son muchos en uno y hasta resistentes a la intemperie.

Avete bisogno di un tavolino aggiuntivo, un vassoio, una ciotola e un cestino – o preferite uno sgabello, una ciotola, un vassoio e un secchio per i rifiuti? I mobili della serie taTu, dallo Zimbabwe, fatti in filo metallico rivestito a polvere sono molte cose in una – e sono resistenti alle intemperie.

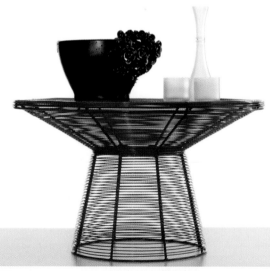

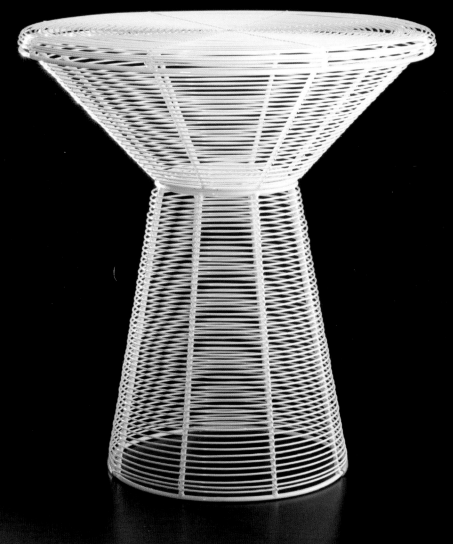

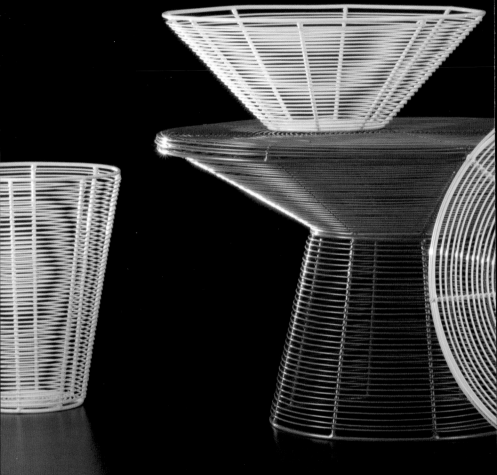

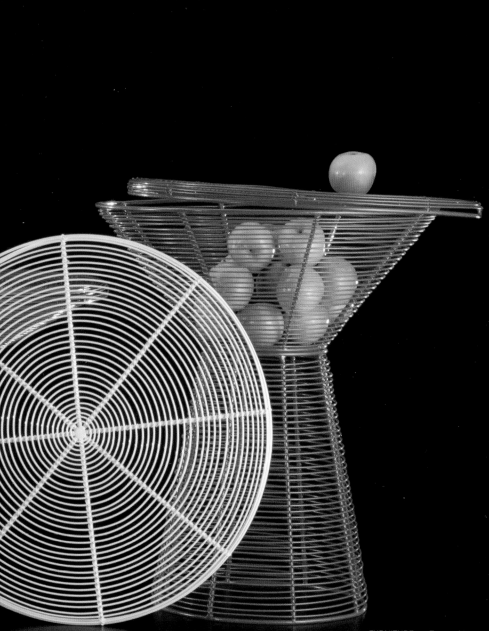

Tennisball Bench

Designer: Tejo Remy and René Veenhuizen
Manufacturer: Tejo Remy and René Veenhuizen, www.remyveenhuizen.nl

A sporty aura surrounds these unusual benches with a base frame of steel tubes that is completely covered with tennis balls which are rejected for selling. At Rotterdam's Museum Boijmans Van Beuningen, this eye-catcher invites visitors to rest a while.

Eine sportliche Aura umgibt diese ungewöhnlichen Bänke, deren Untergestell aus Stahlrohr komplett mit nicht verkäuflichen Tennisbällen ummantelt ist. Im Rotterdammer Museum Boijmans Van Beuningen lädt dieser Eyecatcher die Besucher zum Ausruhen ein.

Une aura sportive entoure ces bancs originaux à la base en tubes d'acier complètement recouverte de vieilles balles de tennis. Au Museum Boijmans Van Beuningen de Rotterdam, cette attraction invite les visiteurs à se reposer un moment.

Estos insólitos bancos están rodeados de un aura deportiva: su armazón de tubo de acero está completamente recubierto de pelotas de tenis. En el Museum Boijmans Van Beuningen de Rotterdam atrae todas las miradas e invita al visitante a descansar en él.

Queste panche inusuali sono circondate da un'aura sportiva, e il loro supporto in tubi d'acciaio è rivestito completamente da palle da tennis usate. Questa attrazione invita i visitatori del Museum Boijmans Van Beuningen di Rotterdam a riposarsi e riprendere fiato.

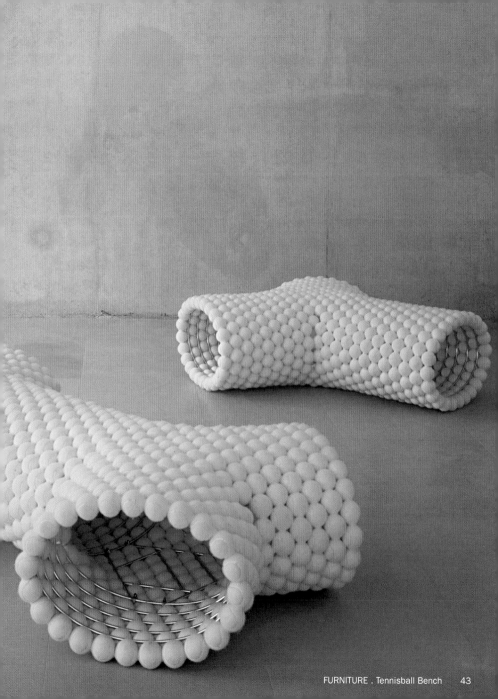

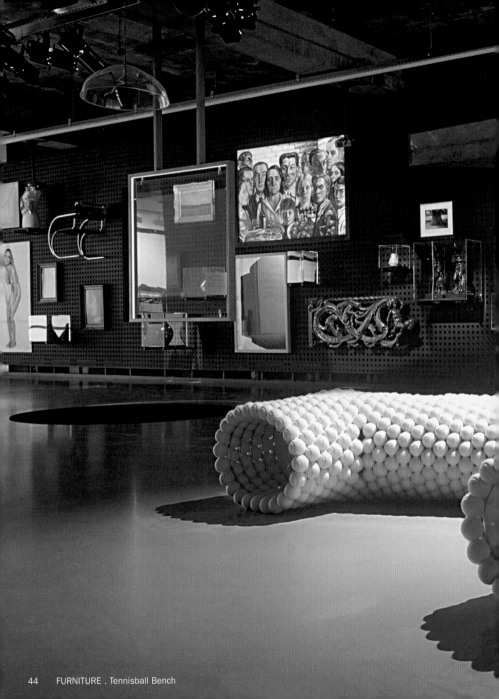

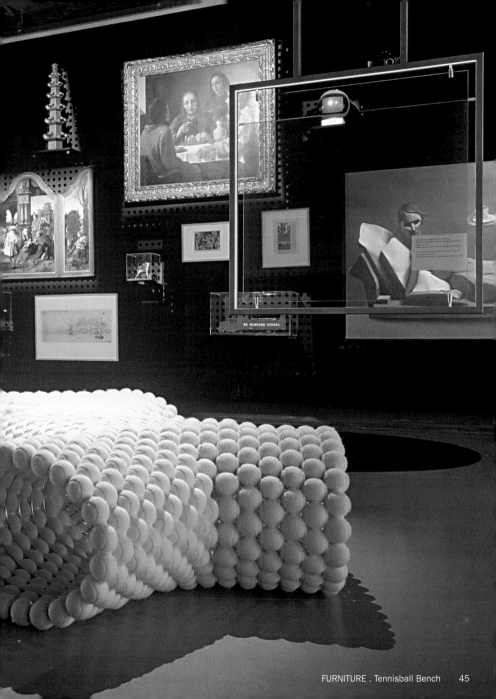

Bendant Lamp

Designer: Jaime Salm
Manufacturer: Mio, www.mioculture.com

Buyers receive this lamp—the steel is laser-cut and powder-coated—in a completely flat package. As the "co-designer," they can assemble it into the right shape and be happy that this light and recyclable product saves resources in its production and transportation.

Der Käufer erhält diese Lampe – der Stahl ist lasergeschnitten und pulverbeschichtet – komplett flach verpackt. Als „Co-Designer" darf er sie in Form bringen, und kann sich freuen, dass dieses leichte und recycelbare Produkt bei Herstellung und Transport Ressourcen schont.

L'acheteur reçoit cette lampe en acier coupé au laser et revêtu par pulvérisation dans un paquet totalement plat. En tant que « co-designer », il l'assemble pour lui donner sa forme et se réjouit que ce produit léger et recyclable soit économe en ressources à la production et au transport.

Aquel que adquiera una de estas lámparas, de acero cortado al láser y con un baño de polvo, las recibe en un paquete plano. Como "co-diseñador", luego les da forma. Le alegrará saber que este producto ecológico y reciclable ahorra recursos durante su elaboración y transporte.

Il compratore riceve questa lampada imballata in modo compatto e piatto – l'acciaio è tagliato con il laser e rivestito a polvere. In qualità di "Co-Designer" può dargli forma e può rallegrarsi del fatto che questo prodotto leggero e riciclabile sia stato prodotto e trasportato tutelando l'ambiente.

 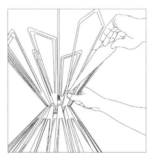 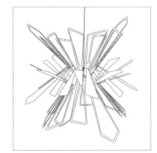

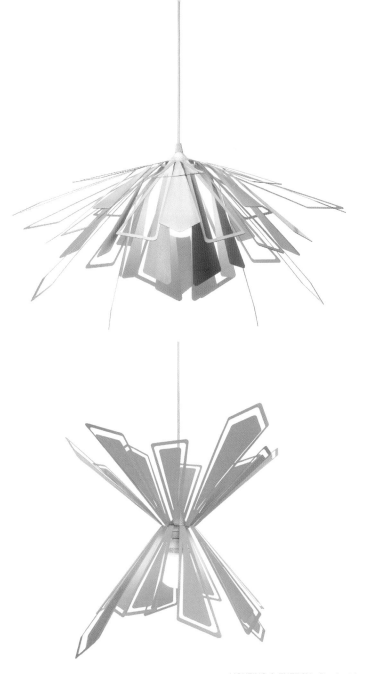

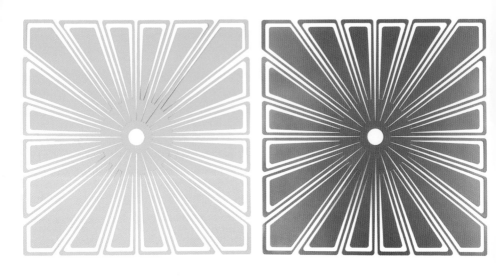

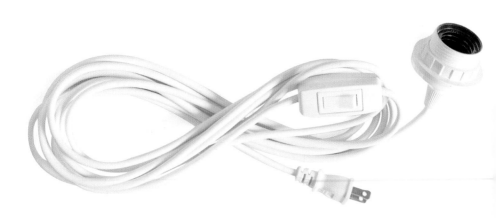

Crush Lamp

Designer: Brendan Young, Studiomold
Manufacturer: Studiomold, www.studiomold.co.uk

The PET bottles for the Crush Lamp series are not recycled but reshaped and immediately used again. In the tradition of readymade objects, the used bottles can be put into a new context and get an amazing second life as a result.

Nicht recycelt, sondern verformt und direkt wiederverwendet sind PET-Flaschen für die Crush Lamp-Serie. In der Tradition des Ready-made-Objekts werden die gebrauchten Flaschen in einen neuen Kontext gesetzt und kommen so zu einem verblüffenden zweiten Leben.

Pour la série Crush Lamp, les bouteilles PET ne sont pas recyclées mais reformées et immédiate-ment réutilisées. Dans la tradition des objets ready-made, les vieilles bouteilles peuvent gagnent un nouveau contexte pour une fabuleuse deuxième vie.

En la serie Crush Lamp, las botellas de PET no se reciclan, sino que se deforman y reutilizan directamente. Siguiendo la tradición de los objetos ready-made, estas botellas se sitúan en un nuevo contexto, viviendo así una sorprendente segunda juventud.

Le bottiglie in PET per la serie Crush Lamp non sono riciclate, ma deformate e riutilizzate diret-tamente. Nella tradizione degli oggetti readymade, le bottiglie usate vengono poste in un nuovo contesto e rinascono così a nuova sorprendente vita.

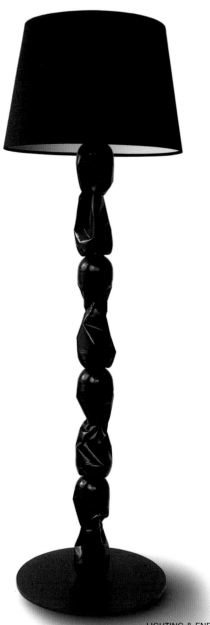

Delight Shade

Designer: Mixko
Manufacturer: Mixko, www.mixko.co.uk

These soft lampshades consist of pure wool felt and are made in the traditional way like a felt hat. The fine patterns like the butterfly outlines are cut by hand and conjure up lighting effects.

Dieser weiche Lampenschirm besteht aus reinem Wollfilz und wird in traditioneller Weise wie ein Filzhut hergestellt. Die feinen Muster wie die Schmetterlingsumrisse sind von Hand geschnitten und zaubern Lichteffekte.

Ces abat-jours mous sont fabriqués en feutre pure laine et de manière traditionnelle comme un chapeau en feutre. Les motifs délicats comme ces silhouettes de papillons sont découpés à la main et forment des effets d'éclairage.

Esta dúctil pantalla está hecha exclusivamente de fieltro de lana. Su confección sigue el modo tradicional de la sombrerería en fieltro. Delicados motivos como las mariposas se cortan a mano y crean fascinantes efectos de luz.

Questo morbido paralume è fatto di puro feltro di lana e viene tradizionalmente prodotto come un cappello di feltro. Le delicate trame come le sagome delle farfalle, sono state ritagliate a mano ed evocano magicamente degli effetti di luce.

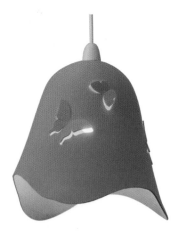 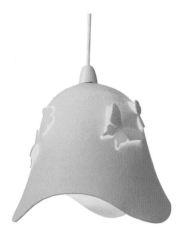

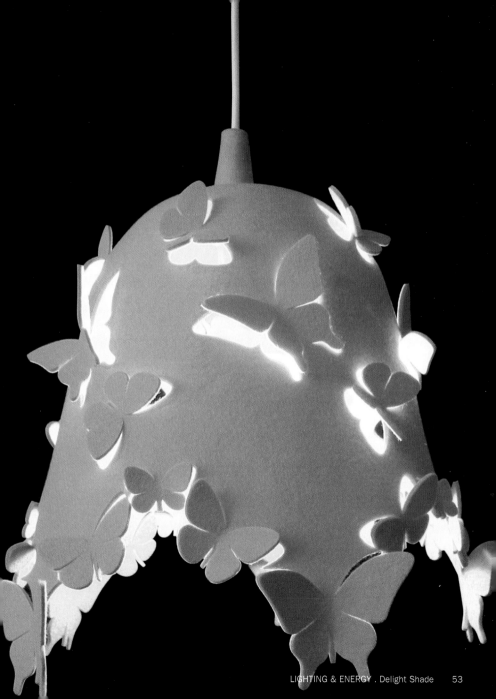

Liese Lotte

Designer: buerofuerform.de
Manufacturer: next home collection, www.next.de

There's just a naked bulb hanging from your ceiling? This is a case for Liese Lotte, the lampshade of recyclable ABS. Because of a longitudinal slot, the shade can simply be put over existing sockets and transform them instantaneously into a complete lamp.

Von Ihrer Decke hängt nur eine nackte Glühbirne? Dies ist ein Fall für Liese Lotte, den Lampenschirm aus recyclebarem ABS. Der Schirm kann aufgrund eines Längsschlitzes vorhandenen Fassungen einfach übergestülpt werden, und verwandelt diese blitzschnell in eine vollwertige Lampe.

Il y a seulement une ampoule nue qui pend de votre plafond ? C'est le cas parfait pour Liese Lotte, l'abat-jour en ABS recyclable. Grâce à une fente longitudinale, il peut être placé simplement au-dessus des douilles existantes et les transformer instantanément en une lampe complète.

¿Que del techo solo cuelga un casquillo con su bombilla? Es el caso perfecto para Liese Lotte, la pantalla de ABS reciclable. Gracias al corte lateral que tienen sus diferentes modelos, la tulipa se coloca sobre la bombilla con suma facilidad, transformándola en un santiamén en toda una lámpara.

Dal vostro soffitto pende solo una lampadina spoglia? Si presenta un caso per Liese Lotte, il lampadario di ABS riciclabile. Il paralume può essere semplicemente calcato sulla montatura esistente grazie a una fessura longitudinale che la trasforma così rapidamente in una lampada a tutti gli effetti.

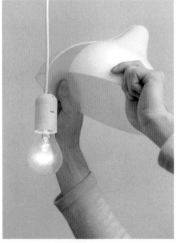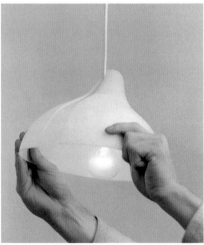

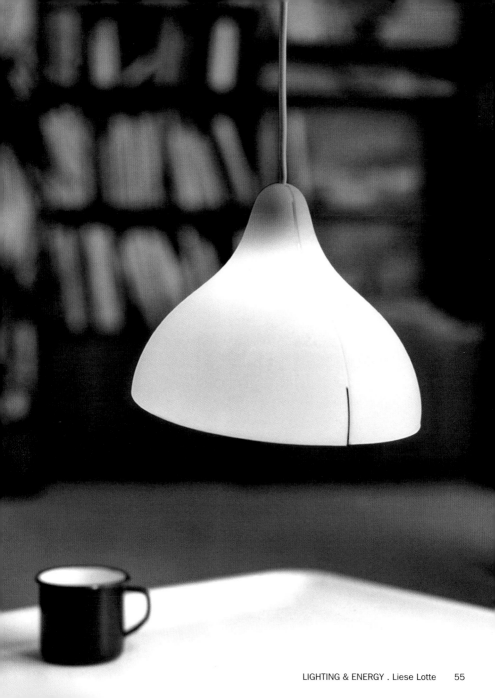

Lunar-Resonant Streetlights

Designer: Civil Twilight
Manufacturer: www.civiltwilightcollective.com

Street lighting in high-density urban areas uses much energy. It also makes it difficult for residents to see the moon and stars. The dimmable Lunar-Resonant Streetlights are designed to adapt to the brightness of the moon and save energy accordingly.

Die Straßenbeleuchtung in Ballungszentren verbraucht viel Energie und führt zudem dazu, dass die Bewohner kaum mehr Mond und Sterne erkennen können. Die dimmbaren Lunar-Resonant Streetlights sollen sich der Helligkeit des Mondes anpassen und entsprechend Energie sparen.

L'éclairage des rues des zones urbaines très peuplées consomme beaucoup d'énergie. Il empêche aussi les résidents de voir la lune et les étoiles. Les Lunar-Resonant Streetlights sont modulables et conçues pour s'adapter à la clarté de la lune et économiser ainsi de l'énergie.

La iluminación de las calles en las grandes ciudades consume grandes cantidades de energía, provocando además que apenas se distingan la luna y las estrellas. Las farolas con regulador de intensidad Lunar-Resonant Streetlights se adaptan a la luminosidad de la luna, ahorrando así energía.

L'illuminazione stradale nei centri ad alta concentrazione urbana consuma molta energia e comporta, inoltre, che gli abitanti non possano più vedere la luna e le stelle. Le Lunar-Resonant Streetlights si possono smorzare e si adattano alla luminosità della luna e di conseguenza risparmiano energia.

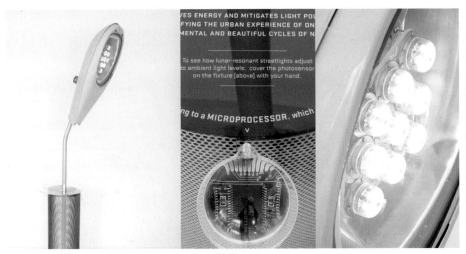

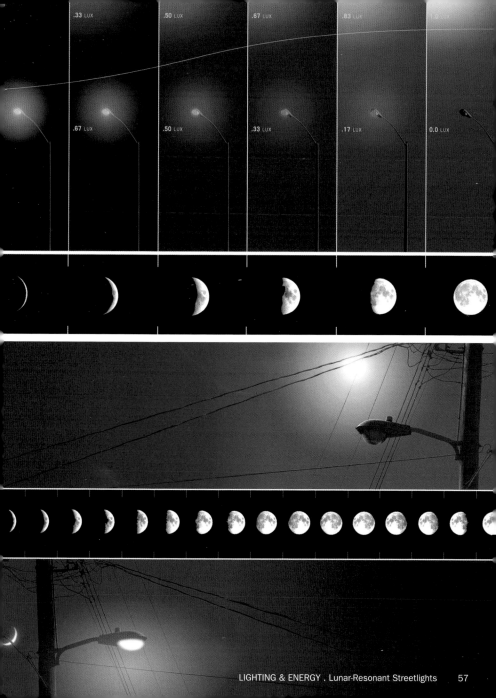

.33 LUX .50 LUX .67 LUX .83 LUX 1.0 LUX

.67 LUX .50 LUX .33 LUX .17 LUX 0.0 LUX

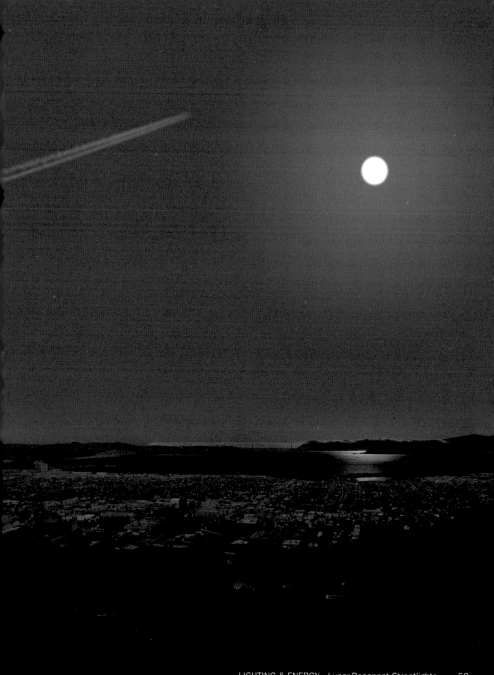

Measuring Light

Designer: Chrissy Angliker
Manufacturer: Chrissy Angliker, www.chrissy.ch

Rolled-up and reshaped measuring tapes have been turned into these original lampshades. The conversion from a tool into a decorative object allows the mass industrial product to turn into an astonishingly individual fixture.

Aufgerollte und verformte Maßbänder lassen diese originellen Lampenschirme entstehen. Die Umfunktionierung vom Werkzeug zum schmückenden Objekt lassen aus einem industriellen Massenprodukt einen erstaunlich individuellen Einrichtungsgegenstand werden.

Des mètres à ruban roulés et reformés ont été transformés en ces abat-jour originaux. La reconversion d'un outil en un objet décoratif permet à un produit industriel de masse de devenir un plafonnier très particulier.

Cintas métricas enrolladas en diferentes formas dan lugar a estas originales pantallas. Su transformación de herramienta de trabajo a objeto decorativo convierte a este producto de fabricación industrial en un elemento que personaliza y engalana nuestro entorno de forma sorprendente.

Questi originali paralumi sono stati creati da metri a nastro arrotolati e deformati. Il loro cambiamento di funzione, dall'attrezzo all'oggetto decorativo, trasforma un prodotto di massa industriale in un oggetto d'arredamento incredibilmente individuale.

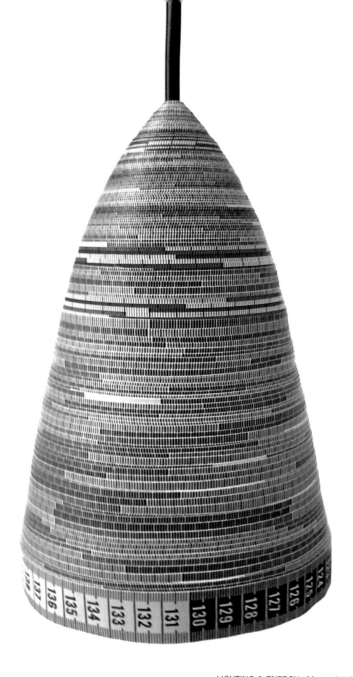

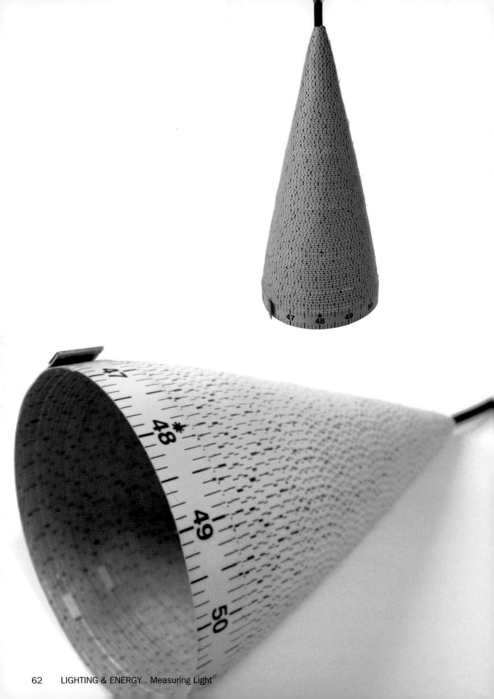

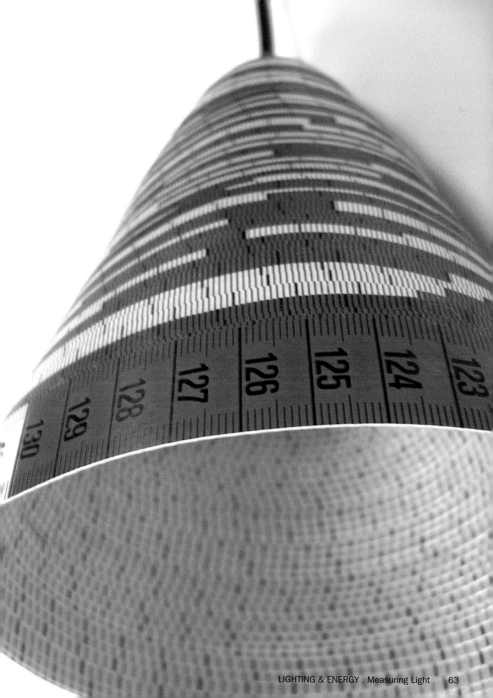

Offshore Wind Energy Converter

Designer: bartsch-design.de
Manufacturer: Multibrid GmbH, www.multibrid.de

This wind energy converter has been rigorously adapted for use on the high seas: A constant excessive pressure in the encapsulated gondola leads to protection against the corrosive sea air and condensation; it also keeps the tower head mass as low as possible.

Diese Windenergieanlage ist konsequent für den Einsatz auf hoher See getrimmt: Ein konstanter Überdruck in der gekapselten Gondel führt zu einem Schutz vor Korrosion durch Seeluft und Kondenswasser; zudem wurde die Turmkopfmasse so gering wie möglich gehalten.

Cette centrale éolienne a été rigoureusement adaptée à l'utilisation en haute mer : une pression forte et constante dans la gondole encapsulée la protège contre l'air marin corrosif et la condensation ; elle laisse également le haut de la tour au niveau le plus bas possible.

Este generador de energía eólica está pensado para su utilización en alta mar. La presión constante en la góndola encapsulada la protege de la corrosión provocada por el aire del mar y la condensación. Asimismo, la masa de la cabeza de la torre se ha reducido al mínimo.

Questo impianto ad energia eolica è fatto per essere usato in alto mare: una costante sovrapressione nella navicella incapsulata protegge dalla corrosiva aria di mare e dall'acqua di condensa; inoltre la massa della testa della torre è stata resa più ridotta possibile.

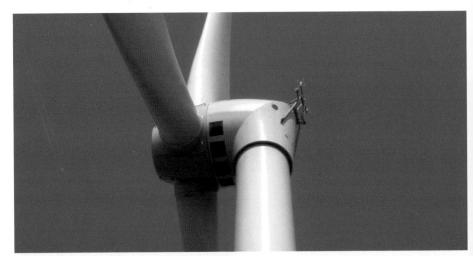

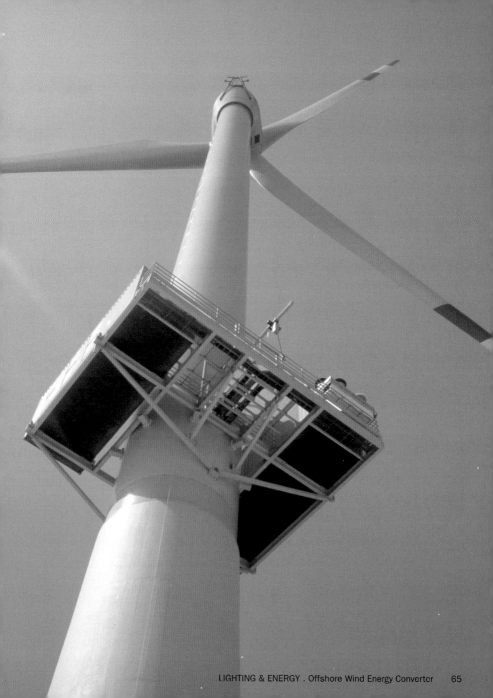

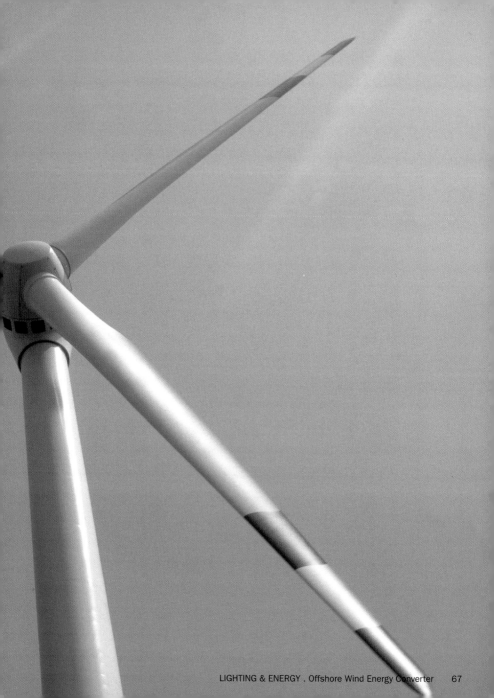

Parans Solar Panels

Designer: Bengt Steneby, Nils Nilsson
Manufacturer: Parans Solar Lighting AB, www.parans.com

The Parans firm promises a natural lighting climate and distinct energy saving through their solar panels. Optical lenses on the roof or the facade channel the sunlight and send it into the interior of the house through light-conducting cables for lighting.

Die Firma Parans verspricht ein natürliches Lichtklima und eine deutliche Energieeinsparung durch ihre Solar Panels. Optische Linsen auf dem Dach oder an der Fassade bündeln das Sonnenlicht und senden es über Lichtleiter-Kabel zur Beleuchtung ins Innere des Hauses.

La société Parans promet un éclairage naturel et des économies d'énergie notables grâce à des panneaux solaires. Des lentilles optiques sur le toit ou la façade canalisent la lumière du soleil et l'envoient à l'intérieur de la maison via des câbles conducteurs de lumière pour l'éclairer.

La compañía Parans garantiza ambientes iluminados con luz natural y un considerable ahorro energético gracias a sus paneles solares. Unas lentes en el tejado o la fachada captan la luz del sol y la envían por cables conductores de luz a las luminarias del interior de la casa.

La ditta Parans promette un clima luminoso naturale e un evidente risparmio energetico grazie ai pannelli solari. Le lenti ottiche sul tetto o sulla facciata convergono la luce solare e la inoltrano tramite cavi ottici all'illuminazione dell'interno della casa.

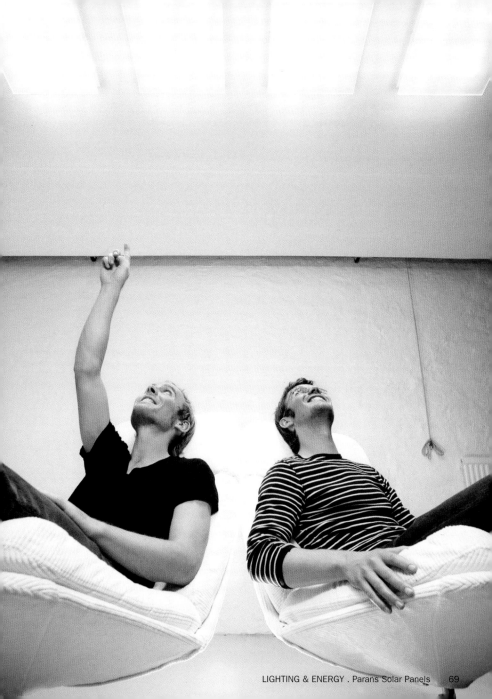

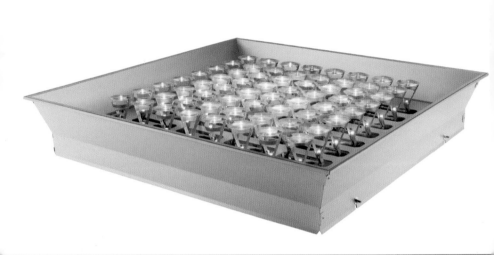

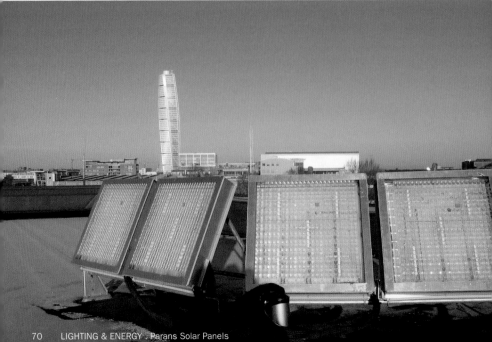

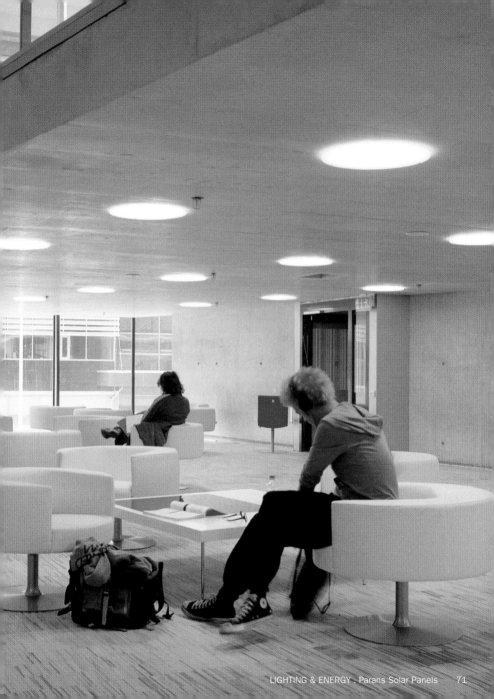

PHOTON – Portable Solar Panel

Designer: Kari Sivonen, Valvomo Architects
Manufacturer: Clothing+ Ltd., www.clothingplus.fi

The rechargeable batteries of cell phones and cameras are always empty precisely when abso-
lutely no outlet is in sight. In order to still make phone calls and take photos at any time, this
mobile solar panel was developed to provide small devices with the necessary energy.

Die Akkus von Handy und Kamera sind immer genau dann leer, wenn garantiert keine Steck-
dose in der Nähe ist. Um trotzdem jederzeit noch telefonieren oder fotografieren zu können,
wurde dieses mobile Solar-Panel entwickelt, das kleine Geräte mit der nötigen Energie versorgt.

Les batteries rechargeables des portables et des appareils photos se vident toujours précisément
quand il n'y a aucune prise en vue. Pour pouvoir continuer à téléphoner et à photographier à tout
moment, on a créé ce panneau solaire mobile qui fournit l'électricité nécessaire à ces appareils.

Las baterías de los móviles y las cámaras siempre se agotan justo cuando no hay enchufes cerca.
Para que, aun siendo así, no tengamos que dejar de telefonear o de hacer fotografías, se ha con-
cebido este panel solar móvil con el que abastecer de energía a los pequeños aparatos.

Le batterie dei cellulari e delle fotocamere si scaricano sempre quando non ci sono prese nelle
vicinanze. Per poter continuare lo stesso a telefonare o fotografare in qualsiasi momento, è
stato sviluppato questo pannello solare mobile che fornisce l'energia necessaria a questi piccoli
apparecchi.

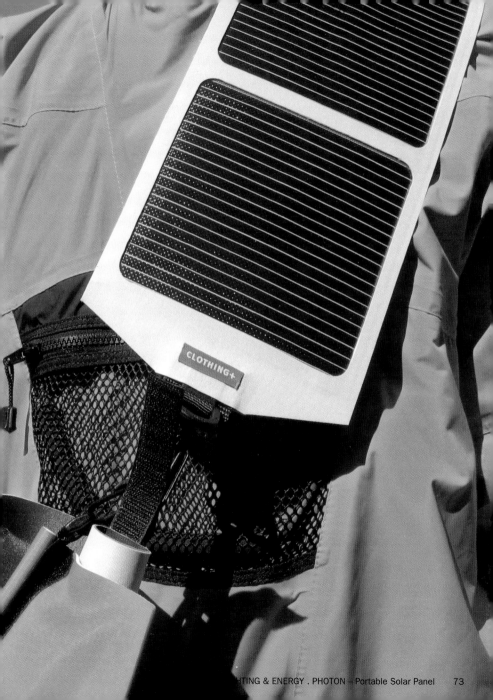

CLOTHING+

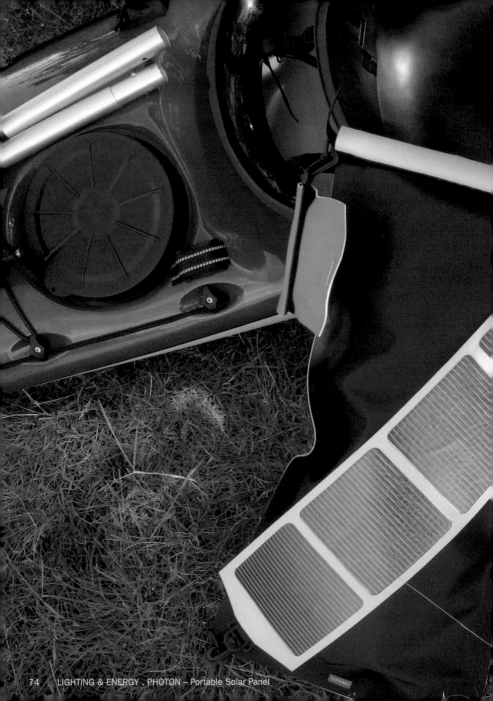

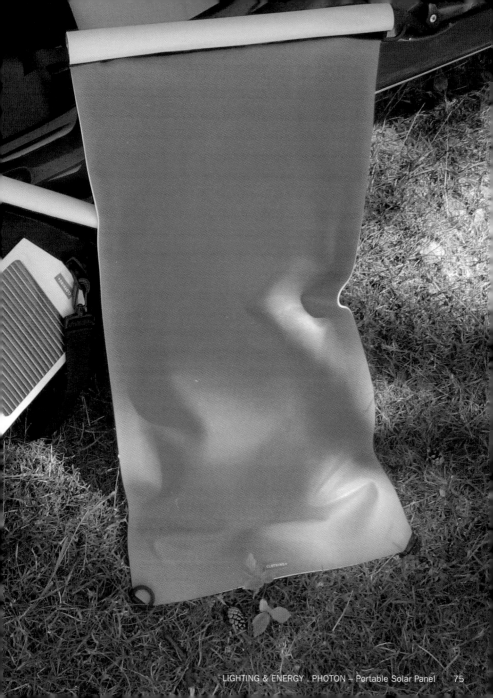

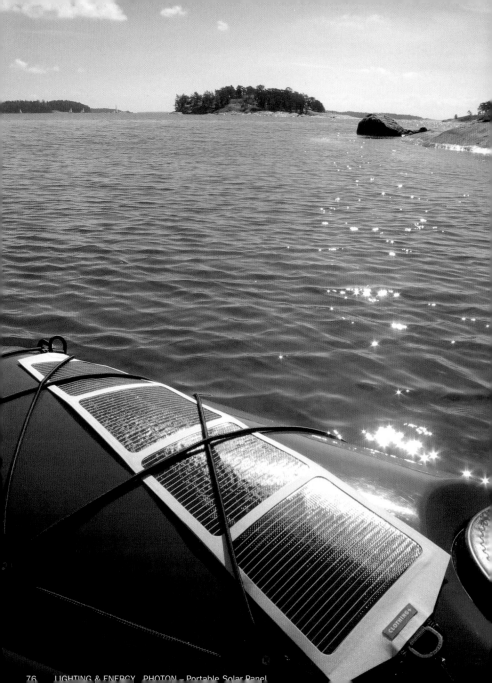

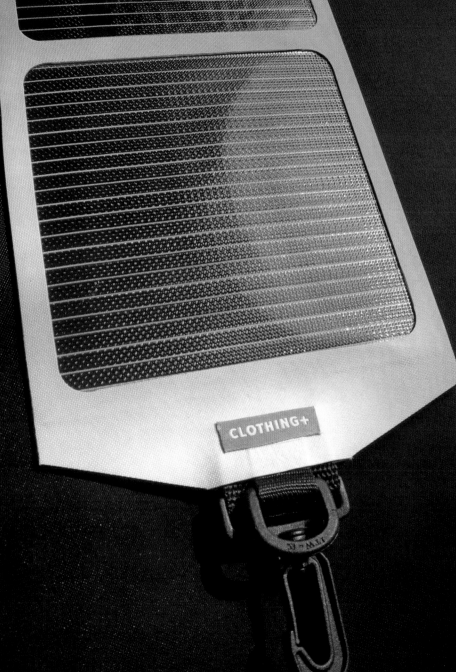

CLOTHING+

bambu

Designer: bambu
Manufacturer: bambu, www.bambuhome.com

Bamboo is a raw material that grows quickly and is also easy to compost. In addition, it is extremely light and stable. The bambu products consist of ecologically cultivated bamboo that is used for making one-way and reusable tableware.

Bambus ist ein schnell nachwachsender und auch leicht zu kompostierender Rohstoff, der zudem noch äußerst leicht und stabil ist. Die bambu-Produkte bestehen aus ökologisch angebautem Bambus, der für die Herstellung von Einweg- und Mehrweggeschirr verwendet wird.

Le bambou est une matière première qui pousse vite et se transforme facilement en compost. En outre, il est extrêmement léger et stable. Les bambous cultivés de manière écologique sont utilisés pour fabriqués de la vaisselle à usage unique et réutilisable.

El bambú es un material que se reproduce con rapidez y que se transforma fácilmente en compost, además de ser muy ligero y robusto. Estos objetos están hechos con bambú de plantaciones ecológicas, utilizado aquí en la fabricación de servicios y vajillas, algunas desechables.

Il bambù è una materia prima che ricresce rapidamente ed è anche facile da ridurre in compost, inoltre è estremamente leggero e stabile. I prodotti di bambu sono fatti di bambù coltivato biologicamente, che viene utilizzato per la produzione delle stoviglie usa e getta e quelle riutilizzabili.

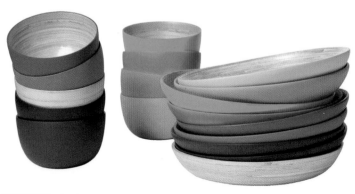

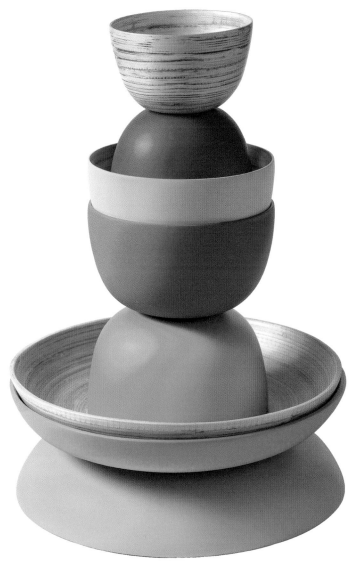

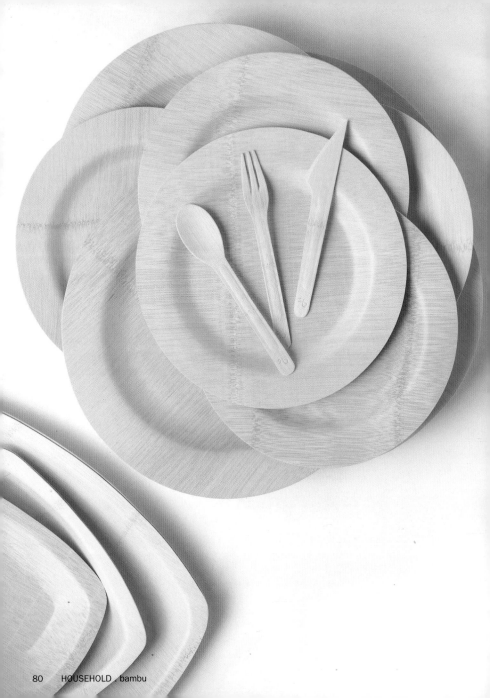

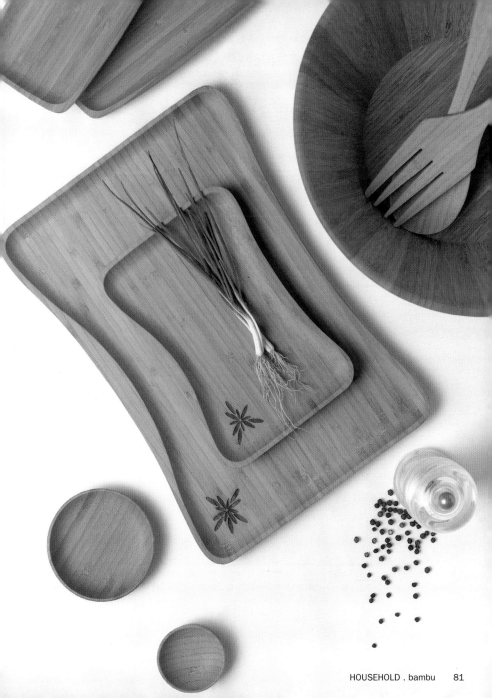

Husque Bowls

Designer: Marc Harrison
Manufacturer: Husque Pty Ltd., www.husque.com

The shells of the Australian macadamia nut are actually waste from the food industry. But when they are ground and joined with a polymer, they turn into "husque"—a natural material that can be made into beautiful and useful everyday objects.

Die Schalen der australischen Macadamianuss sind eigentlich Abfälle aus der Lebensmittelindustrie. Doch zermahlen und mit einem Polymer verbunden wird aus ihnen „Husque", ein natürliches Material, aus dem schöne und nützliche Alltagsgegenstände gefertigt werden können.

Les coquilles des noix de macadamia australiennes sont des déchets de l'industrie agroalimentaire. Mais une fois moulues et associées à un polymère, elles se transforment en « husque », un matériau naturel dont on peut faire des objets à la fois esthétiques et pratiques.

Las cáscaras de las nueces australianas de macadamia no son más que desechos de la industria alimentaria. No obstante, molidas y amasadas con un polímero, se obtiene "husque", un material natural con el que fabricar bellos y útiles objetos de lo más práctico en nuestro quehacer diario.

Il guscio delle noci di Macadamia australiana in realtà sono rifiuti dell'industria alimentare. Ma se vengono tritati e legati con un polimero, ne risulta il "husque", un materiale naturale, con il quale è possibile produrre oggetti della vita quotidiana.

 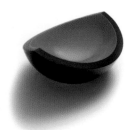

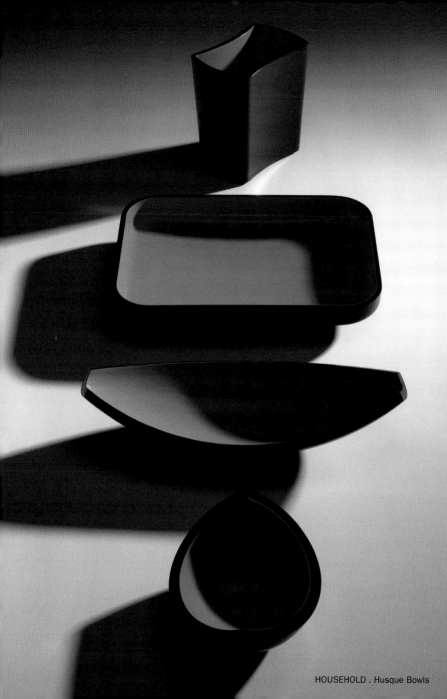

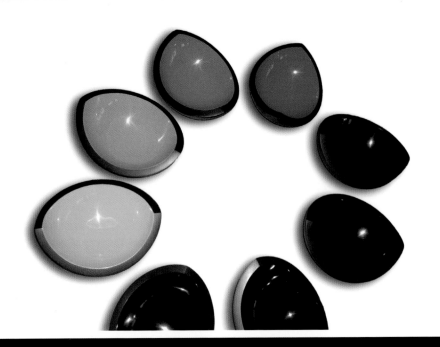

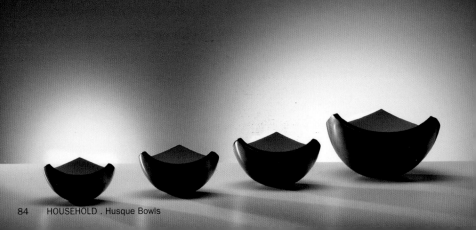

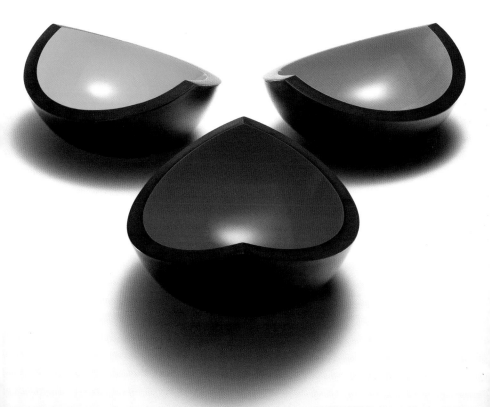

Modular Bird House

Designer: Resolution: 4 Architecture
Manufacturer: Resolution: 4 Architecture, www.re4a.com

The modular bird houses are made in a 3D printing process (stereo lithography or laser sinter), which permits production in one piece. The geometry can also be scaled as desired in size. The data can be sent all over the world and printed directly on site.

Die modularen Vogelhäuser sind im 3D-Druckverfahren (Stereolithografie oder Lasersinter) produziert, das die Herstellung in einem Stück erlaubt; zudem ist die Geometrie beliebig in der Größe skalierbar. Die Daten lassen sich weltweit verschicken und direkt vor Ort ausdrucken.

Ces nichoirs modulaires sont fabriqués grâce à un processus d'impression 3D (stéréo lithographie ou sintérisation laser) qui produit une pièce unique et dont la géométrie peut être adaptée à toutes les tailles. Les données peuvent être envoyées dans le monde entier et imprimées directement sur site.

Estos nidos modulares se producen con técnicas de impresión en 3D (estereolitografía o sinterizado por láser) que permiten su fabricación en una sola pieza, permitiendo además que su geometría se adapte al tamaño a escala. Los datos se envían a cualquier parte del mundo y desde allí se pueden imprimir.

Le casette modulari per gli uccelli sono prodotte con la procedura di stampa in 3D (stereolitografia e laser sinter), che consente la produzione in un solo pezzo; inoltre la geometria ha una misura regolabile a piacere. I dati si possono inviare in tutto il mondo e stampare direttamente in loco.

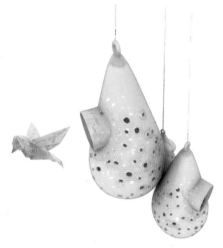

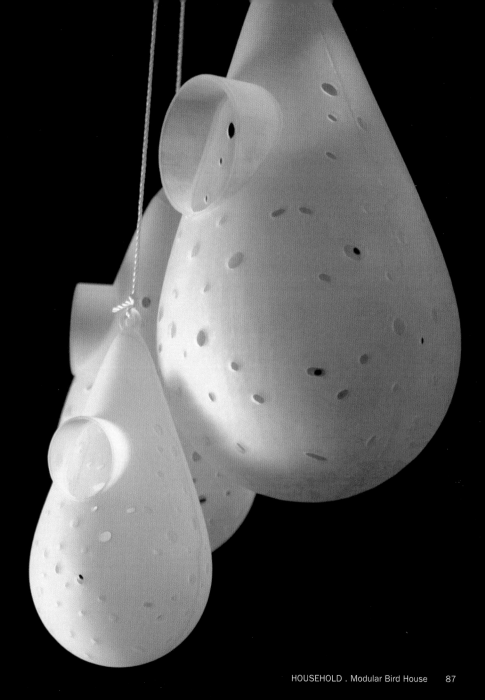

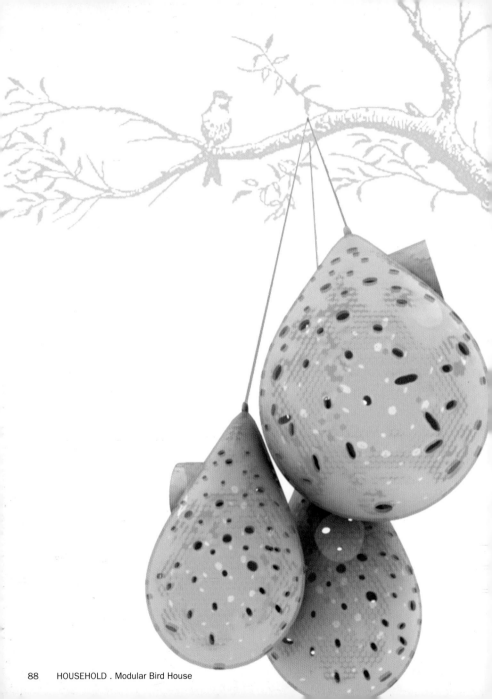

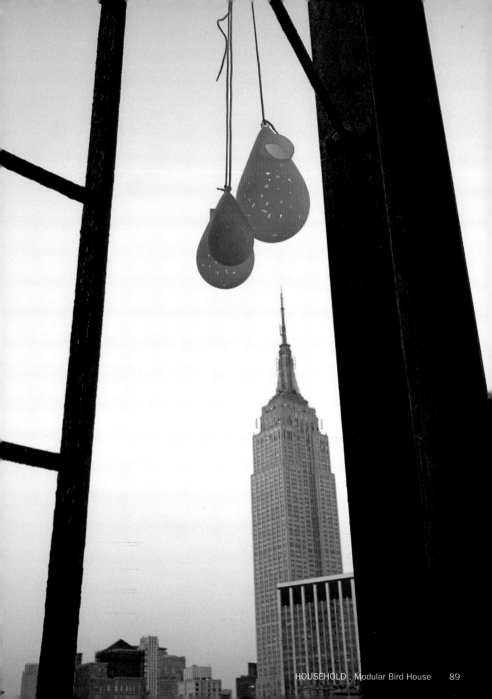

New Heirlooms

Designer: CJ O'Neill
Manufacturer: CJ O'Neill, www.cjoneill.co.uk

Used tableware is found in large quantities at flea markets or in junk shops. These discarded products have been transformed into exclusive one-of-a-kind pieces for the New Heirlooms series — printed with floral motifs that the designer found at the wayside on trips through Denmark.

Jede Menge gebrauchtes Geschirr ist auf Flohmärkten oder in Trödelläden zu finden. Für die Serie New Heirlooms wurden diese ausrangierten Produkte in exklusive Einzelstücke verwandelt — bedruckt mit floralen Motiven, die die Designerin auf Reisen durch Dänemark am Wegesrand fand.

On peut trouver de grandes quantités de vaisselle usagée dans les marchés aux puces ou les bazars. La collection New Heirlooms transforme ces rebuts en des pièces uniques exclusives, imprimées de motifs floraux que la designer a trouvés sur la route pendant ses voyages au Danemark.

Las vajillas usadas se encuentran a montones en los rastros o en tiendas de segunda mano. La serie New Heirlooms ha transformado estos objetos desechados en piezas exclusivas. Su diseñadora encontró los motivos florales al borde de los caminos en un viaje por Dinamarca.

Le stoviglie usate sono reperibili in quantità nei mercatini o presso i rigattieri. Per la serie New Heirlooms questi prodotti scartati sono stati trasformati in pezzi unici esclusivi — stampati con motivi floreali, trovati dalla designer a bordo strada durante i suoi viaggi in Danimarca.

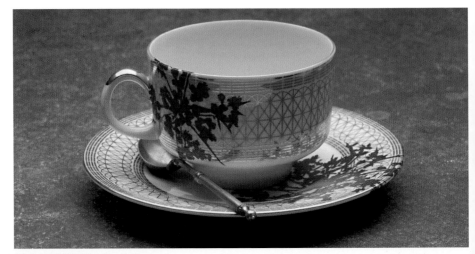

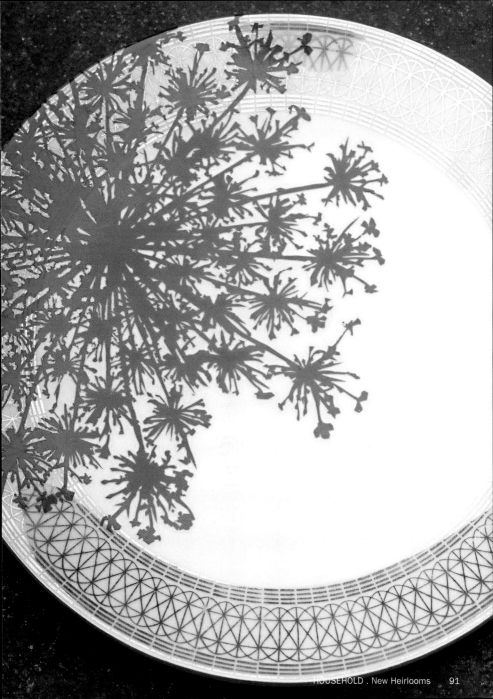

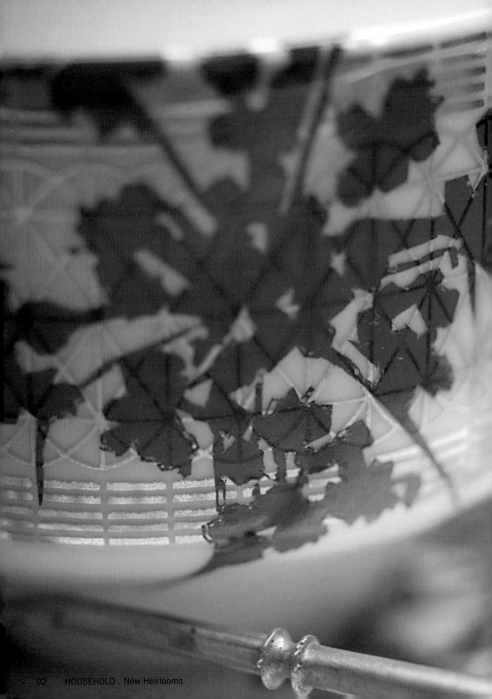

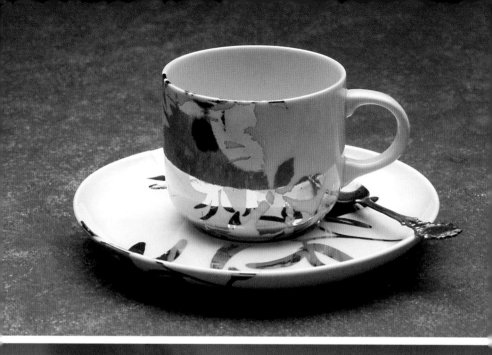

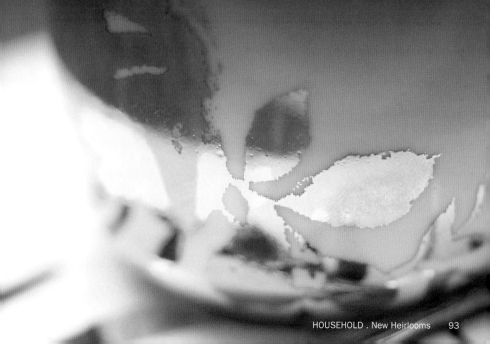

Paperwork

Designer: Hannah Lobley
Manufacturer: Hannah Lobley, www.hl-web.net

The idea for these objects came to the designer when she forgot a book in the rain one day: After it dried, it turned into a solid block that could be worked on like a piece of wood. The result is housewares that still reveal something of their old purpose as Yellow Pages or crossword magazines.

Die Idee zu diesen Objekten kam der Designerin als sie einmal ein Buch im Regen vergaß: Nach Trocknung war es wieder ein fester Block, der sich nun wie ein Stück Holz bearbeiten ließ. So entstehen Haushaltswaren, die noch etwas über ihre alte Bestimmung als Gelbe Seiten oder Kreuzworträtselhefte verraten.

La designer a eu l'idée de ces objets en oubliant un livre sous la pluie pendant une journée : une fois séché, il s'est transformé en un bloc solide et facile à travailler comme du bois. Le résultat : des articles ménagers qui révèlent toujours un peu leur ancien usage, pages jaunes ou magazines de mots croisés.

La diseñadora concibió estos objetos al olvidársele un libro bajo la lluvia. Tras secarse, se había convertido en un bloque que solo podía trabajarse como un trozo de madera. Así surgieron estos artículos de menaje, que apenas dejan entrever su origen como páginas amarillas o crucigramas.

La designer ha avuto l'idea per questi oggetti quando un giorno dimenticò un libro sotto la pioggia: una volta asciutto era un blocco rigido che si poteva lavorare come il legno. Così i casalinghi raccontano ancora della loro vecchia destinazione di pagine gialle o riviste di parole incrociate.

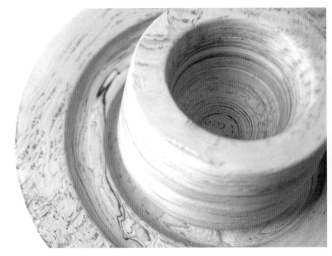

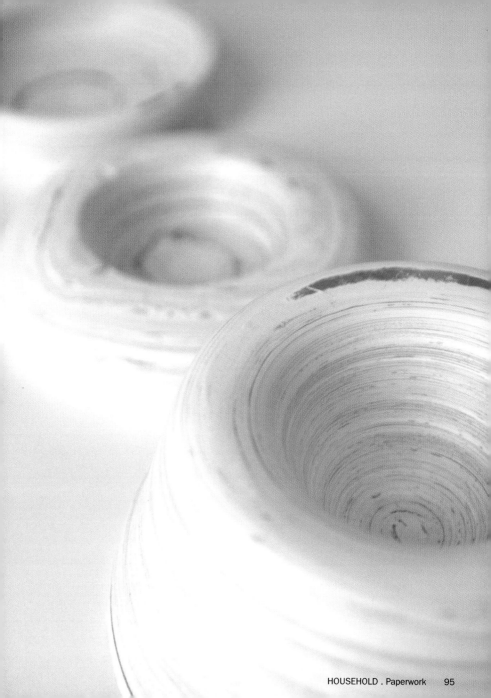

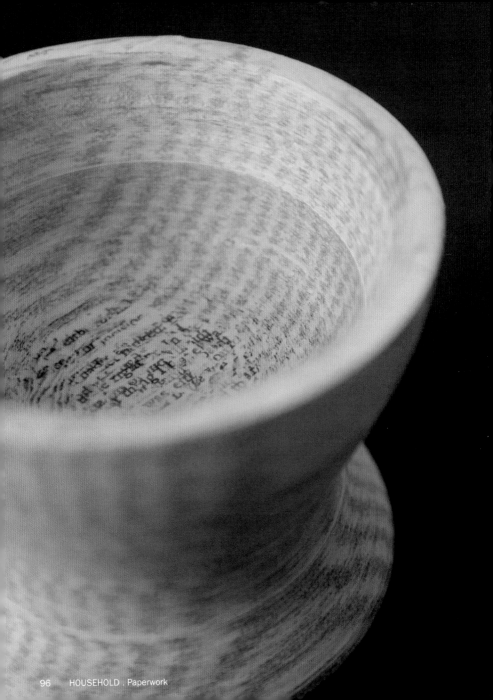

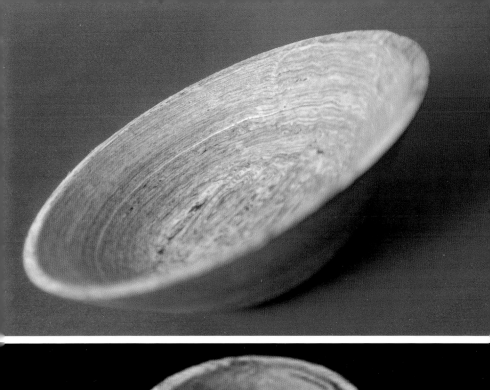

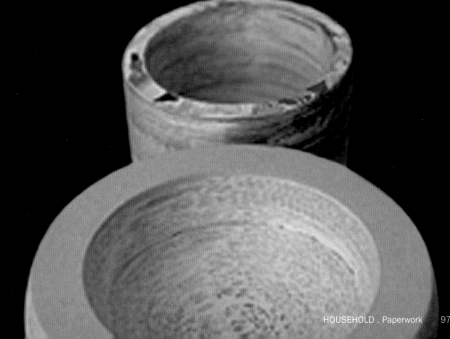

SoftBowls

Designer: Jaime Salm, Roger Allen
Manufacturer: Mio, www.mioculture.com

Hatmakers can produce not only hats but also unusual bowls, which is demonstrated by the SoftBowls. These soft home accessories of woolen felt come from the USA, where they are manufactured in a traditional way using local materials.

Hutmacher können nicht nur Hüte, sondern auch außergewöhnliche Schalen fertigen, wie die SoftBowls beweisen. Diese weichen Wohnaccessoires aus reinem Wollfilz stammen aus den USA, wo sie in traditioneller Weise aus lokalen Materialien hergestellt werden.

Les chapeliers peuvent produire non seulement des chapeaux mais aussi des bols originaux, ce que démontrent les SoftBowls. Ces accessoires mous en feutre de laine proviennent des Etats-Unis, où ils sont fabriqués de manière traditionnelle à partir de matériaux locaux.

Los sombreros no fabrican únicamente sombreros, sino también singulares cuencos, como así lo prueban los SoftBowls. Estos flexibles accesorios para el hogar de fieltro de lana proceden de EE. UU., donde se confeccionan de forma tradicional con materiales autóctonos.

I cappellai sanno creare non solo cappelli, ma anche delle ciotole straordinarie, come dimostrano i SoftBowls. Questi morbidi accessori d'arredamento di puro feltro di lana vengono dagli USA, dove vengono prodotti tradizionalmente con materiale locale.

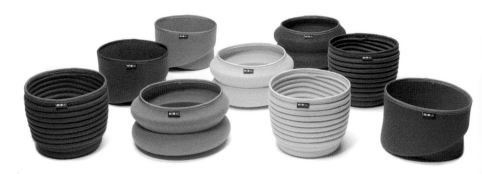

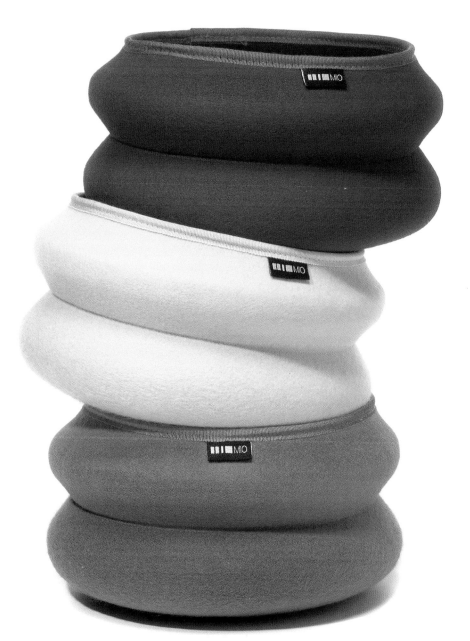

Sycamore Ceiling Fan

Designer: Michael Hort and Danny Gasser of Sycamore Technology, Sydney, Australia
Manufacturer: Sycamore Technology Pty Ltd., www.sycamorefan.com

The shape of this single-wing ceiling fan was inspired by the seed capsules of the Australian sycamore tree. The organic styling of the asymmetrical and dynamically balanced rotor blade guarantees energy-efficient and quiet operation.

Die Form dieses einflügeligen Deckenventilators ist inspiriert von der Samenkapsel des australischen Sycamore-Baumes. Die organische Formgebung des asymmetrischen und dynamisch ausbalancierten Rotorblattes garantiert einen energieeffizienten und leisen Einsatz.

La forme de ce ventilateur de plafond à aile unique s'inspire des capsules de graines des sycamore australiens. Le style organique de la pale asymétrique et équilibrée sur le plan dynamique garantit un fonctionnement économe en énergie et silencieux.

La línea de este ventilador de techo de una sola aspa se inspira en la vaina de la simiente del sycamore. La forma orgánica del aspa rotatoria, de equilibrio asimétrico y dinámico, garantiza su eficiencia energética y la ausencia de ruido cuando se pone en funcionamiento.

La forma di questo ventilatore da soffitto a un'elica è stato ispirato dalle capsule di semi dell'albero australiano del Sycamore. La modellatura organica della pala del rotore bilanciata asimmetricamente e dinamicamente, garantisce un utilizzo a risparmio energetico e silenzioso.

CEILING

BACK VIEW LEFT VIEW

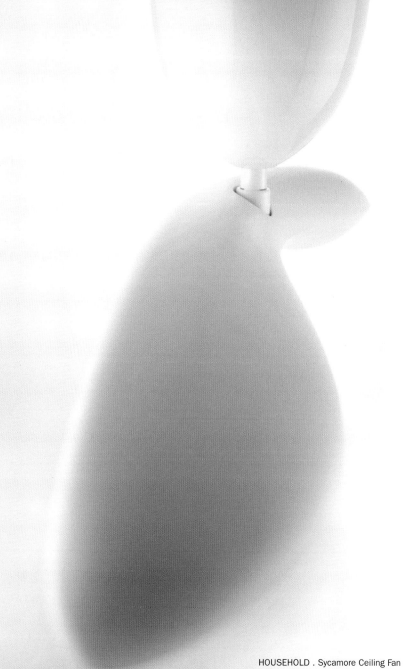

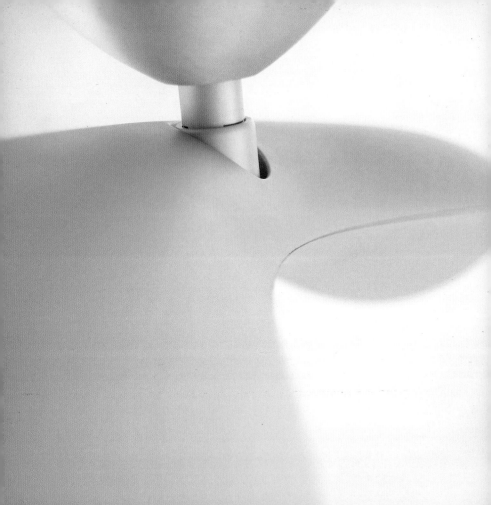

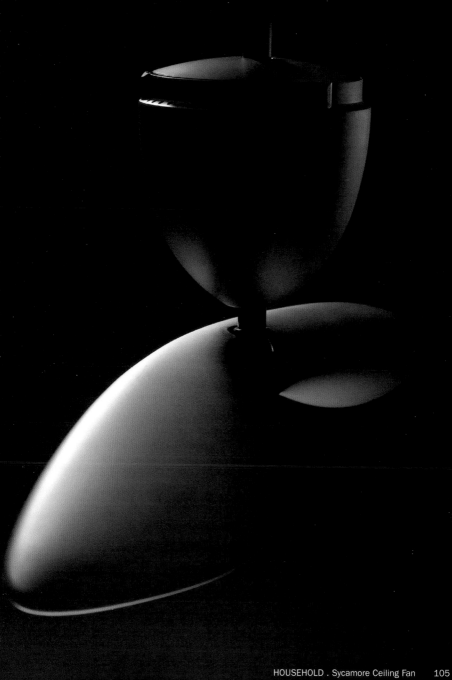

tranSglass

Designers: Emma Woffenden and Tord Boontje
Manufacturer: Artecnica Inc., www.artecnicainc.com

What the Dutch designer Tord Boontje initially made by hand on his own is now being success-fully produced in Guatemala. Exceptionally beautiful vases and consumer goods are created from used glass here—a combination of contemporary design and traditional handicraft.

Was der niederländische Designer Tord Boontje zunächst noch selbst von Hand fertigte, wird inzwischen erfolgreich in Guatemala produziert. Hier entstehen aus Altglas außergewöhnlich schöne Vasen und Gebrauchsartikel – eine Verbindung von aktuellem Design und traditionellem Handwerk.

Ce que le designer néerlandais Tord Boontje faisait à l'origine tout seul à la main est maintenant un produit à succès fabriqué au Guatemala. On y crée des vases à la beauté exceptionnelle et des objets de consommation qui marient design contemporain et artisanat traditionnel.

Lo que en un primer momento fabricaba con sus propias manos el diseñador holandés Tord Boontje, hoy es un éxito y se produce en Guatemala. Con vidrio reciclado se crean jarrones y artículos de consumo de belleza extraordinaria que asocian diseño actual y artesanía tradicional.

Quanto inizialmente fatto a mano dal designer Tord Boontje, ora viene prodotto con successo in Guatemala. Qui vengono creati da vetro usato dei vasi e degli articoli di consumo straordinaria-mente belli – un'unione tra design contemporaneo e manifattura tradizionale.

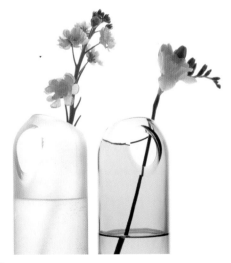

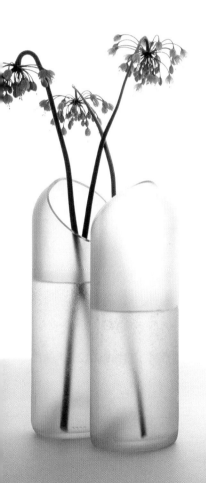
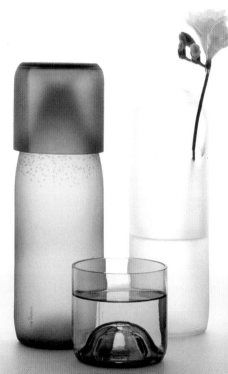

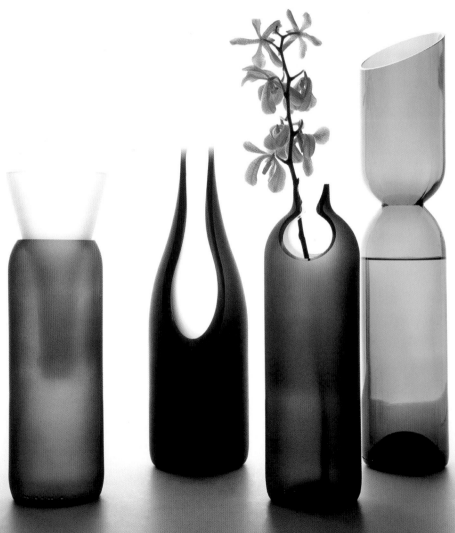

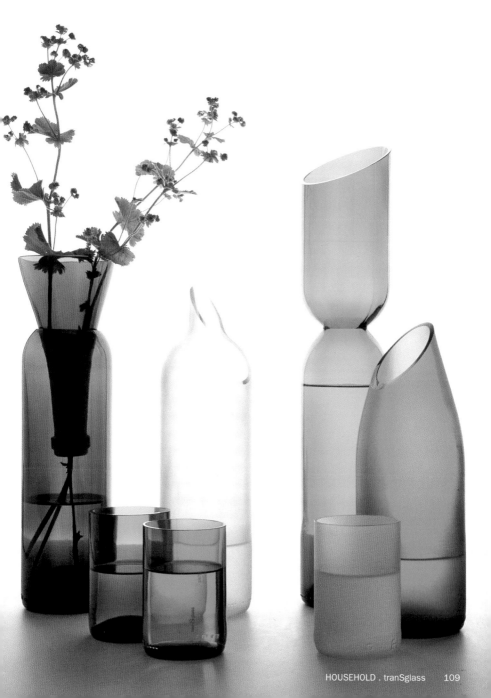

Wall Mounted CD Player

Designer: Naoto Fukasawa
Manufacturer: MUJI, www.muji.com

Mounted flat on the wall, this minimalist CD player has a low profile and doesn't take any precious space. The function of this compact device is reduced to just playing music, which starts when the cord is pulled.

Flach an der Wand angebracht nimmt sich dieser minimalistische CD-Player optisch sehr zurück und beansprucht keinen kostbaren Stellplatz. Die Funktion dieses kompakten Gerätes ist auf die reine Musikwiedergabe reduziert, welche durch einen Zug an der Schnur gestartet wird.

Installé à plat sur le mur, ce lecteur de CD minimaliste n'attire pas l'attention et ne gaspille pas d'espace précieux. Cet appareil compact a pour seule fonction de jouer de la musique, qui commence quand le cordon est tiré.

Colocado en la pared de forma vertical, este reproductor de CD minimalista ni llama en exceso la atención ni precisa de un valioso espacio en el suelo. La función de este aparato tan compacto se reduce a la reproducción de música, que se inicia tirando del cordón.

E' affisso piatto sul muro, questo lettore CD minimalistico che dal punto di vista ottico si tiene molto in disparte e non ruba alcuno spazio prezioso. La funzione di questo apparecchio compatto è ridotta alla pura riproduzione di musica che viene avviata tirando la fune.

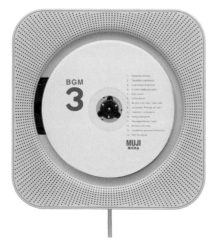

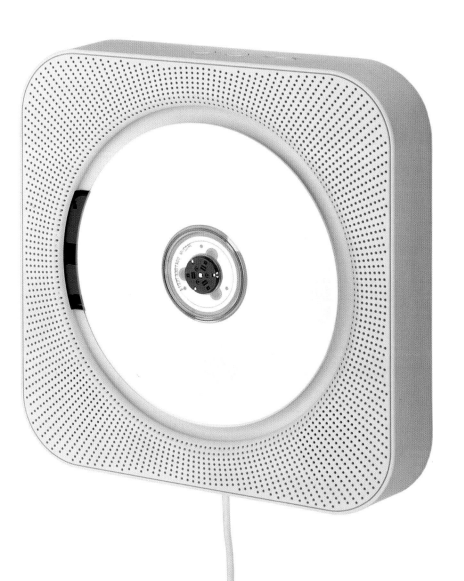

Candeloo

Designer: Stefane Barbeau and Duane Smith
Manufacturer: Vessel, www.vessel.com

The designers of these little lights know that the nightly path to the bathroom can often be very exciting for children. Once the battery has been charged (safely via induction), the colorful lamps keep watch next to the bed for a number of hours and are also portable.

Die Designer dieser kleinen Leuchten wissen, dass der nächtliche Weg zur Toilette für Kinder oft höchst aufregend sein kann. Ist die Batterie (sicher per Induktion) aufgeladen, wachen die bunten Lämpchen einige Stunden neben dem Bett und sind auch für den mobilen Einsatz bereit.

Les designers de ces petites lampes savent qu'aller aux toilettes la nuit peut être inquiétant pour un enfant. Une fois que la batterie est chargée (en tout sécurité grâce à l'induction), les lampes colorées veillent tout près du lit pendant plusieurs heures et peuvent aussi être transportées.

Los diseñadores de estas lamparillas saben que, de noche, el camino al aseo puede ser de lo más emocionante para un niño. Con la batería cargada (de forma segura por inducción), estas lamparillas de colores velan unas horas junto a la cama, además de poder llevarlas consigo.

I designer di questi piccoli lumi sanno che il cammino notturno verso la toilette per i bambini spesso può trasformarsi in un'avventura. Quando le batterie sono cariche (sicure grazie all'induzione), le colorate lampadine vigilano alcune ore accanto al letto e sono anche pronte per essere usate.

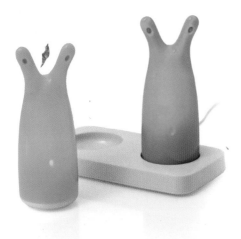

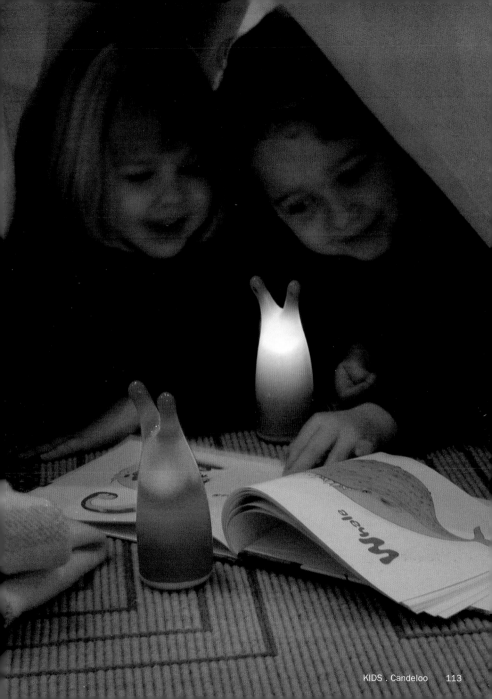

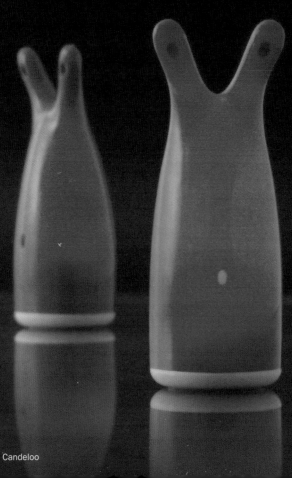

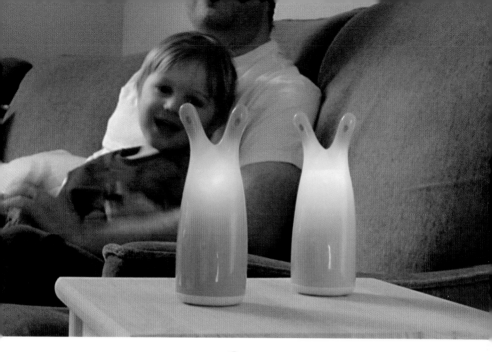

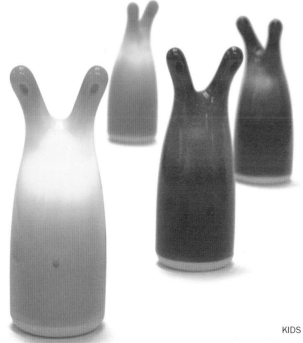

Felt Rocks

Designer: Todd MacAllen and Stephanie Forsythe of molo
Manufacturer: molo, www.molodesign.com

The production of polishing disks for optical lenses results in lump-like collections of wool remnants that slowly become matted. These lumps are no longer destined to be waste but transformed into a universal toy that stimulates children's imaginations.

Bei der Herstellung von Polierscheiben für optische Linsen kommt es zu klumpenförmigen Ansammlungen von Wollresten, die langsam verfilzen. Diese Klumpen müssen nun kein Abfall mehr sein, sondern verwandeln sich in universelles Spielzeug, das die kindliche Fantasie anregt.

La production de disques à polir pour lentilles optiques génère des restes de laine en forme de boulettes qui finissent par s'emmêler. Ces boulettes ne sont plus destinées à être jetées mais sont transformées en un jouet universel qui stimule l'imagination des enfants.

En la elaboración de discos de pulido para lentes se acumulan restos de lana a modo de grumos que van formando una madeja. Esos burujos han dejado de echarse a la basura y se han transformado en juguetes de ámbito universal que consiguen estimular la fantasía infantil.

Nella produzione dei dischi lucidatori per lenti ottiche si creano degli accumuli di resti di lana che lentamente si infeltriscono. Questi grumi ora non sono più da considerare dei rifiuti, ma si trasformano in giocattoli universali che stimolano la fantasia dei bambini.

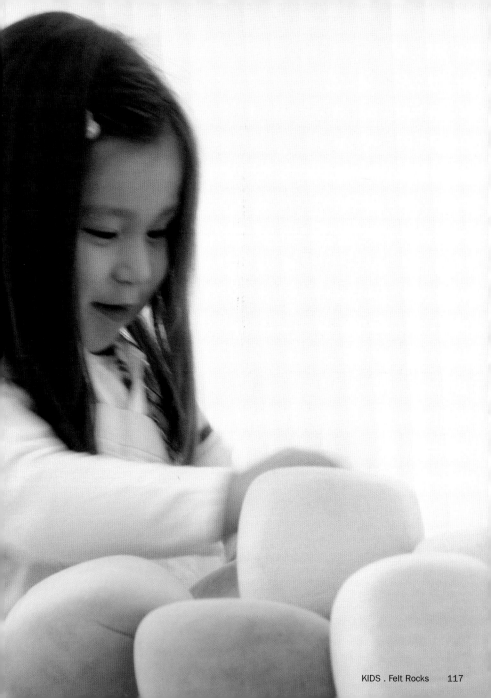

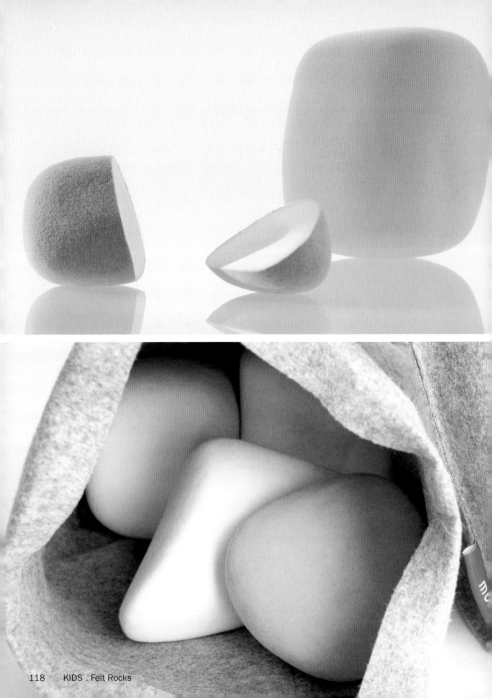

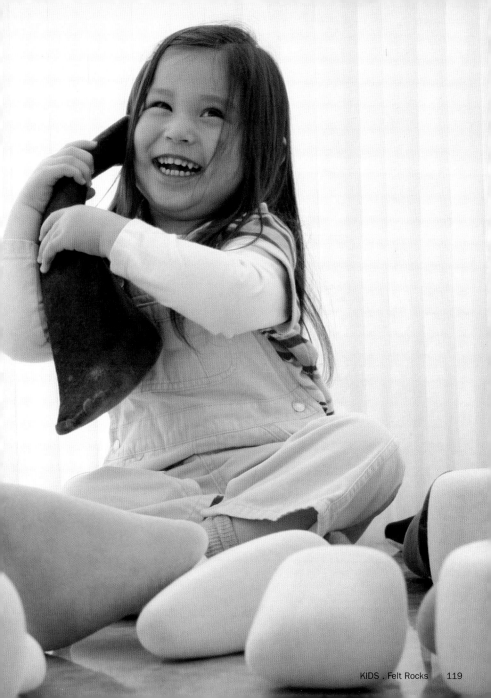

Fingermax

Designer: buerofuerform.de
Manufacturer: fingermax gmbh, www.fingermax.de

Paint with the finger or with the brush? With the durable Fingermax, young—and even older—artists can combine both. The special top stays on each finger through its individual form and offers a completely new painting experience.

Mit dem Finger malen oder mit dem Pinsel? Mit dem langlebigen Fingermax können kleine und auch große Künstler beides verbinden. Der besondere Aufsatz hält durch seine spezielle Form auf jedem Finger und bietet ein völlig neues Malerlebnis.

Peindre au doigt ou à la bouche ? Avec le Fingermax, les jeunes artistes (et les moins jeunes) peuvent combiner les deux. L'embout spécial reste sur chaque doigt grâce à sa forme particulière et offre une expérience de peinture complètement nouvelle.

¿Pintar con los dedos o con pincel? Con el Fingermax, veterano ya en el mercado, pequeños y grandes artistas pueden hacer las dos cosas. Gracias a su forma especial, se sujeta en cualquier dedo y es toda una experiencia pictórica.

Disegnare con il dito o con il pennello? Con il duraturo Fingermax sia piccoli che grandi artisti possono unire le due tecniche. L'inserto particolare si adatta, grazie alla sua speciale forma, a ogni dito e offre un'esperienza nell'arte del disegno completamente nuova.

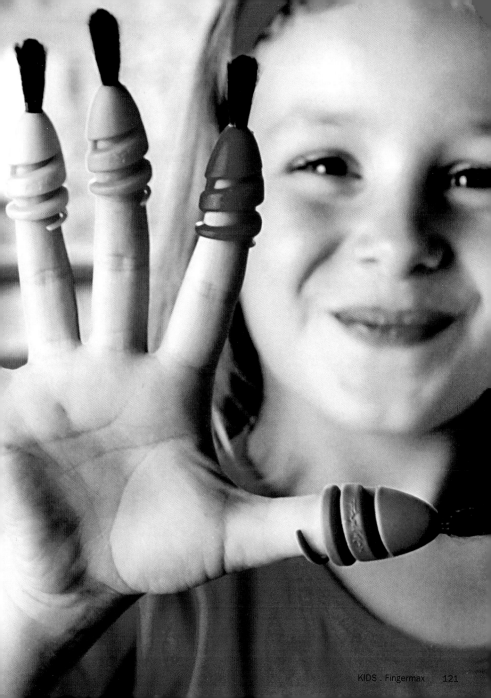

Ioline Crib

Designer: Kalon Studios
Manufacturer: Kalon Studios, www.kalonstudios.com

Arabesque windows inspired the design language of this crib. What's practical: The bed "grows" with the baby and can later be transformed into a place for older children to sleep. It is made of bamboo laminated wood and can be transported in a flat package.

Arabische Fenster inspirierten die Formsprache dieses Babybetts. Praktisch: Das Bett „wächst mit" und kann später in eine Schlafstatt für Kleinkinder umgewandelt werden. Hergestellt wird es aus Bambus-Schichtholz und lässt sich flach verpackt transportieren.

Les fenêtres arabes ont inspiré le langage formel de ce berceau très pratique : il « grandit » avec bébé et se transforme par la suite en un lit pour enfant. Il est fait de contreplaqué de bambou et peut être transporté dans un emballage plat.

Las ventanas arábigas sirvieron de inspiración al lenguaje formal de esta cuna. Es muy práctica, pues crece "con el bebé", para transformarse más adelante en una cama para el pequeño. Se elabora en madera multilámina de bambú y se transporta en un paquete plano.

Le finestre arabe ispirano il linguaggio delle forme di questo lettino per bebè. Pratico: il letto "cresce insieme al bambino" e può successivamente essere trasformato in un giaciglio per bambini. E' fatto di compensato di bambù ed è possibile trasportarlo in una confezione piatta e compatta.

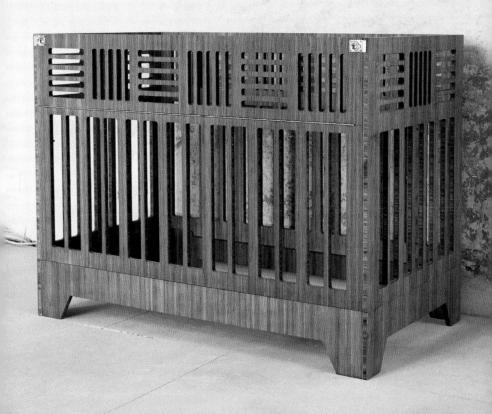

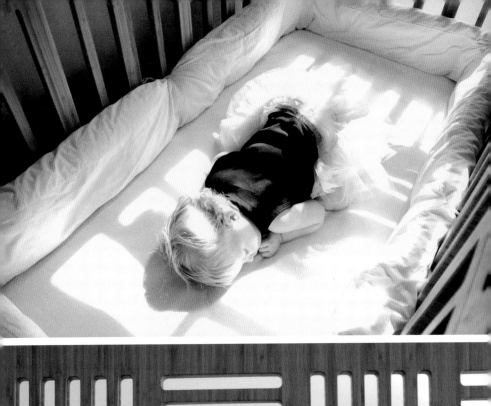

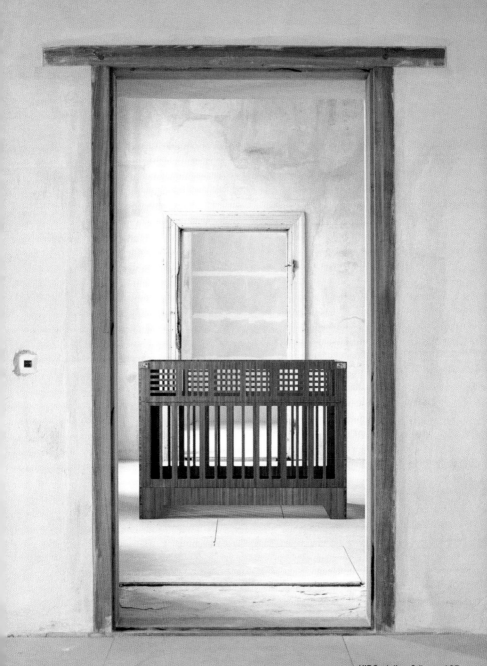

Little Errol and Friends

Designer: Lucy Jane Batchelor
Manufacturer: Lucy Jane Batchelor, www.lucyjanebatchelor.co.uk

These little colorful characters are made by hand from recycled woolen fabric in Great Britain. The relatively vague, not completely defined shape is intended to invite children to personalize and complete the figures. They can also be repaired easily.

Diese kleinen bunten Charaktere werden in Großbritannien von Hand aus recyceltem Wollgewebe hergestellt. Die relativ vage, nicht komplett definierte Form soll die Kinder dazu einladen, die Figuren zu personalisieren und zu ergänzen; zudem können sie problemlos repariert werden.

Ces petits personnages colorés sont fabriqués à la main en Grande-Bretagne à partir de laine recyclée. Leur forme relativement vague, pas totalement définie, est conçue pour inciter les enfants à les personnaliser et à leur donner leur aspect final. Ils peuvent aussi être facilement réparés.

Estos pequeños personajes llenos de color se elaboran a mano en Gran Bretaña con lanas recicladas. Sus formas, hasta cierto punto ambiguas y por definir, facilitan que los más pequeños personalicen y complementen las figuras; y si hay desperfectos, se pueden reparar sin problemas.

Questi piccoli personaggi colorati vengono prodotti a mano in Gran Bretagna da tessuto di lana riciclata. La forma relativamente vaga e non completamente definita ha lo scopo di invitare i bambini a personalizzare e integrare le figure; che inoltre possono essere riparate senza problemi.

Toy Animals

Designer: MUJI
Manufacturer: MUJI, www.muji.com

The Japanese company MUJI manufactures amusing cuddly toys out of recycled yarn remnants. Since the yarn isn't dyed again, this creates an original pattern that gives the little animals their characteristic and unique appearance.

Aus wiederverwendeten Garnresten fabriziert das japanische Unternehmen MUJI lustige Kuscheltiere. Da das Garn nicht neu eingefärbt wird, entsteht eine einzigartige Musterung, die den kleinen Tieren ihr charakteristisches und einmaliges Aussehen verleiht.

La société japonaise MUJI fabrique de drôles de jouets tout doux à partir de restes de fils. Comme la fibre n'est pas reteintée, cela crée un motif original qui donne aux petits animaux leur caractère et leur apparence unique.

A partir de la reutilización de restos de hilo, la firma japonesa MUJI produce estos graciosos muñecos de trapo. Como los hilos no vuelven a tintarse, cada uno de los diseños es exclusivo, lo que hace que estos pequeños animales sean por sus características ejemplares únicos.

L'impresa giapponese MUJI fabbrica dei divertenti peluche fatti di resti di fili da cucito. Visto che il filo non viene ricolorato, nascono delle trame singolari che donano ai piccoli animali il loro aspetto caratteristico e unico.

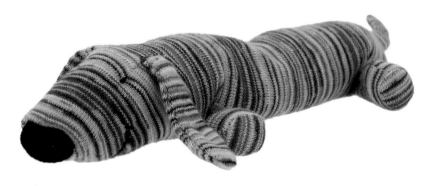

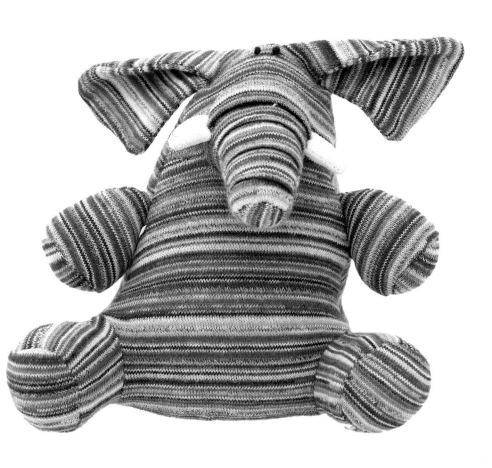

AppleSac

Designers: Jared Rasmussen, Matthew Watkins
Manufacturer: AppleSac, www.applesac.com

Good transportation protection is very important for the long life of a laptop. An unusual bag for this purpose is the AppleSac—its soft lining is polyester fleece and robust natural materials of hemp or jute are used as the outer material.

Guter Transportschutz ist für ein langes Leben eines Laptops höchst wichtig. Eine ausgefallene Tasche zu diesem Zweck ist der AppleSac – sein weiches Futter ist Polyesterfleece, als Außenmaterial werden die robusten natürlichen Materialien Hanf oder Jute verwendet.

Une bonne protection lors du transport est très importante pour la durée de vie d'un ordinateur portable. L'AppleSac est une sacoche originale créée dans ce but : son revêtement doux est en laine polaire et des matériaux naturels robustes comme le chanvre ou la jute sont utilisés pour l'extérieur.

Ir bien protegido durante su transporte es esencial para prolongar la vida de un portátil. Una bolsa un tanto peculiar para este fin es la AppleSac. Su forro, de lana de poliéster, es muy suave. Para el exterior se emplean materiales naturales más robustos como el cáñamo o el yute.

Una buona protezione per il trasporto è di vitale importanza per la durata di un laptop. Una borsa originale adatta a questo scopo è la AppleSac – il suo morbido interno è in pile di poliestere, come materiale esterno vengono utilizzati materiali naturali come la canapa o la iuta.

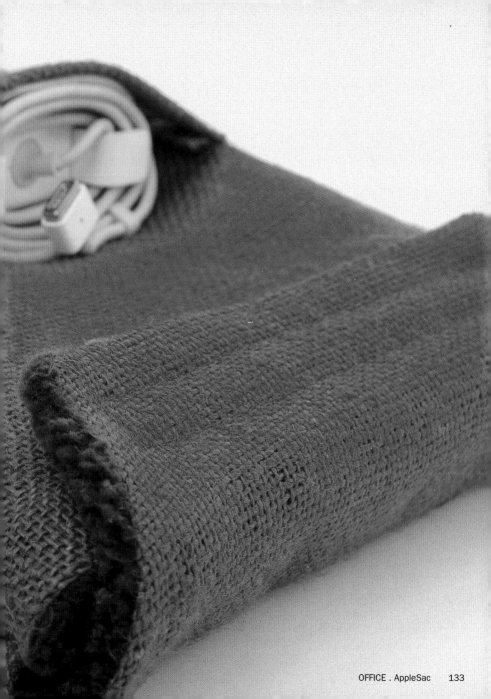

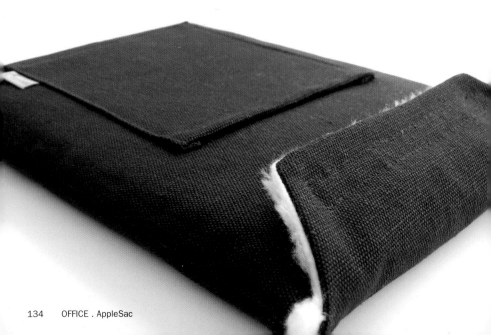

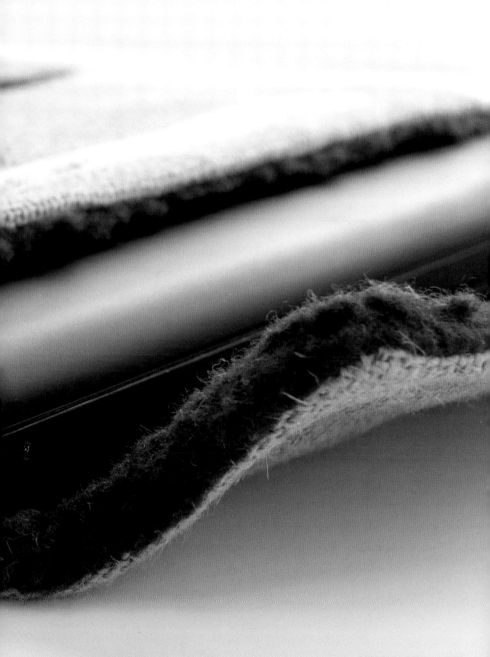

Philips Digital Pocket Memo 9600 Series

Designer: GP designpartners GmbH
Manufacturer: Philips, www.philips.com

This dictating machine was created as a professional tool for everyday use by lawyers and doctors. Philips developed it in cooperation with the Ecodesign Institute of the Vienna Technical University, which could reduce the environmental impact of this product by up to 85 %.

Dieses Diktiergerät ist als professionelles Werkzeug für den Alltag von Anwälten und Medizinern entstanden. Es wurde von Philips in Kooperation mit dem Institut Ecodesign der TU Wien entwickelt, was die Umweltbelastung durch das Produkt um bis zu 85 % reduzieren konnte.

Ce dictaphone a été créé comme un outil professionnel pour l'utilisation quotidienne des avocats et des médecins. Philips l'a créé en coopération avec l'Institut d'Ecodesign de l'Université Technique de Vienne, qui a permis de réduire de 85 % son impact environnemental.

Este dictáfono está pensado como herramienta profesional para el quehacer diario de abogados y médicos. Resultado de la cooperación entre Philips y el Instituto Ecodesign de la Universidad Técnica de Viena, este producto llega a reducir su impacto medioambiental hasta en un 85 %.

Questo dittafono è stato creato come attrezzo professionale per la vita quotidiana per avvocati e medici. La Philips, in collaborazione con l'Istituto Ecodesign dell'Università Tecnica di Vienna, lo ha sviluppato, il che ha portato a una riduzione del 85 % dell'inquinamento ambientale del prodotto.

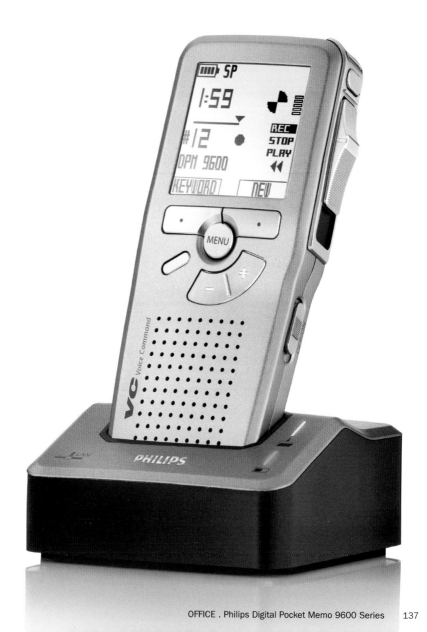

EcoDisc

Designer: ODS Technology GmbH
Manufacturer: ODS Business Services Group GmbH, www.ods.com

The EcoDisc uses just 50 % of the resources required for the manufacture and transport of a standard DVD. In order to achieve this, the material strength has been reduced by half. In addition, the EcoDisc is easier to recycle since it only consists of one layer.

Die EcoDisc verbraucht nur 50 % der Ressourcen, die für die Herstellung und den Transport einer handelsüblichen DVD anfallen. Um dies zu erreichen, wurde die Materialstärke um die Hälfte reduziert. Zudem ist die EcoDisc einfacher recycelbar, da sie nur aus einer Scheibe besteht.

L'EcoDisc utilise seulement 50 % des ressources requises pour la fabrication et le transport d'un DVD standard. Pour atteindre ce résultat, la résistance matérielle a été réduite de moitié. De plus, l'EcoDisc est plus facile à recycler car il fabriqué à partir d'une seule couche.

Un EcoDisc consume únicamente el 50 % de los recursos necesarios en la fabricación y el transporte de un DVD convencional. Para conseguirlo, se reduce a la mitad la resistencia del material. Además, el EcoDisc es es más fácil de reciclar, ya que no se compone de una sola capa.

L'EcoDisc consuma solo il 50 % delle risorse necessarie per la produzione e il trasporto dei DVD comunemente in commercio. Per raggiungere questo risultato lo spessore del materiale è stato ridotto della metà. Inoltre l'EcoDisc è più facile da riciclare, visto che è fatto di uno solo strato.

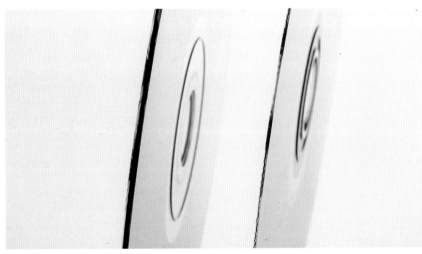

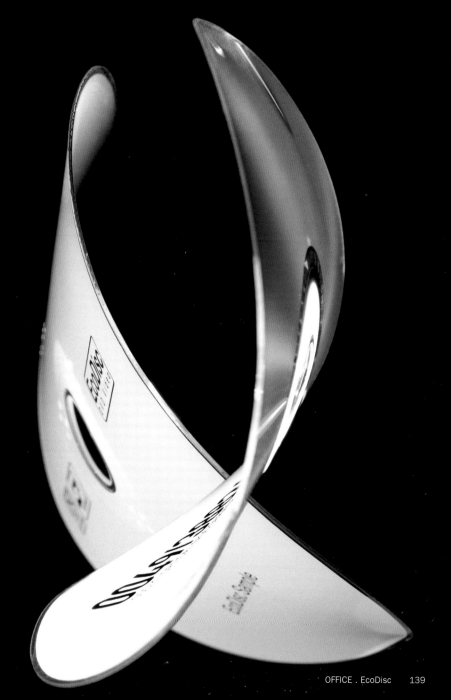

Giddyup Rocking Chair

Designer: Tim Wigmore Design
Manufacturer: Tim Wigmore Design, www. timwigmore.co.nz

These special seats—discarded horse saddles on a plywood base—are not just made for children but intended as an ergonomic alternative to a customary chair. The concept of active sitting takes on a completely new dimension.

Diese speziellen Sitzgelegenheiten – ausrangierte Pferdesättel auf einem Schichtholzgestell – sind nicht etwa nur für Kinder produziert, sondern sollen ergonomische Alternativen zu einem herkömmlichen Stuhl sein. Der Begriff des aktiven Sitzens erhält eine völlig neue Dimension.

Ces sièges spéciaux, des selles démontées sur en base de contreplaqué, ne sont pas conçus uniquement pour les enfants mais pour une alternative ergonomique à la chaise ordinaire. Le concept d'assise active prend une tout nouvelle dimension.

Estos asientos tan especiales —sillas de montar desechadas sobre una estructura de madera multicapa— no se fabrican pensando tanto en los niños, sino que son una alternativa ergonómica a la silla convencional. Estar sentado de manera activa cobra una dimensión totalmente novedosa.

Questi speciali posti a sedere – delle selle dismesse posizionate su supporti di compensato – non sono stati prodotti per bambini, ma rappresentano delle alternative ergonomiche alla sedia tradizionale. Il concetto di sedere in modo attivo viene investito di una dimensione completamente nuova.

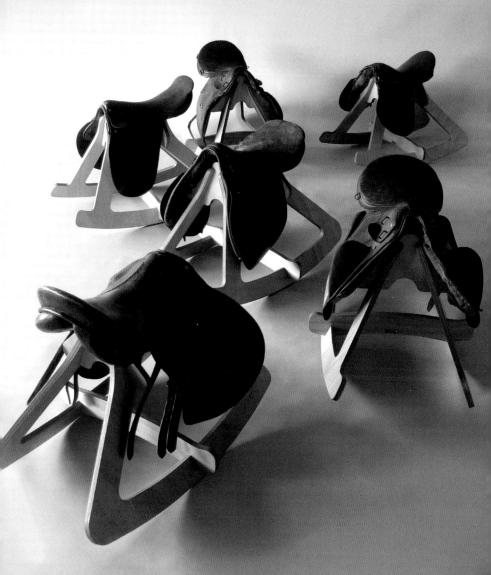

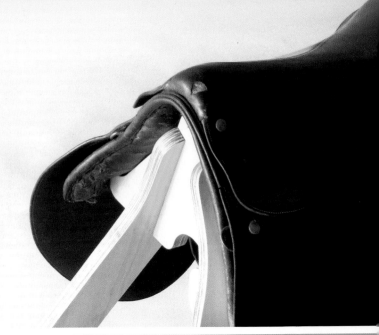

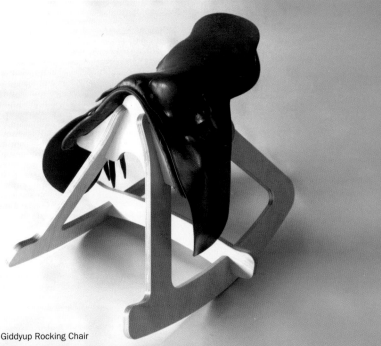

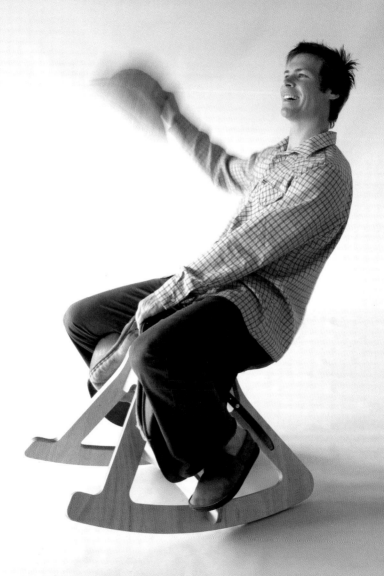

HP rp5700 Desktop PC

Designer: Hewlett-Packard
Manufacturer: Hewlett-Packard, www.hp.com

The manufacturer HP has used the principles of its DfE (Design for Environment) program for this PC. This includes material savings, avoiding the use of paint, including measures for saving energy and avoiding noise, as well as reducing packaging.

Bei diesem PC hat der Hersteller HP die Regeln seines DfE (Design for Environment) Programms angewandt. Materialeinsparung gehört ebenso dazu, wie der Verzicht auf eine Lackierung, Maßnahmen zur Energieeinsparung und zur Geräuschvermeidung sowie eine Reduzierung der Verpackung.

Le fabricant HP a mis en pratique les principes de son programme DfE (Design for Environment) pour ce PC. Ledit programme prévoit des économies de matériaux, d'énergie et de peinture, et également des mesures pour éviter les bruits et réduire les emballages.

HP, fabricante de este ordenador, ha aplicado la normativa de su programa DfE (Design for Environment: diseño por el medio ambiente), que incluye tanto el ahorro de materiales como la ausencia de lacado, el ahorro energético, la disminución de ruido y la reducción de empaquetado.

Con questo PC il produttore HP ha applicato la regola del suo programma DfE (Design for Environment). Ne fa parte anche il risparmio di materiale, oltre alla rinuncia alla laccatura, ai provvedimenti per il risparmio energetico e la riduzione dei rumori, e a una riduzione dell'imballaggio.

Kalidro

Designer: Stefan Brodbeck
Manufacturer: Steelcase, www.steelcase.com

The Kalidro desk is produced in a way that conserves resources and is designed for long use. In its construction, special attention was paid to a minimal use of materials and the interchange-ability of its components. It's also recyclable up to 99 %.

Der Schreibtisch Kalidro wird ressourcenschonend hergestellt und ist für einen langen Einsatz konzipiert. Bei seiner Konstruktion wurde besonders auf einen reduzierten Materialeinsatz und die Austauschbarkeit seiner Komponenten geachtet. Zudem ist er zu 99 % recyclebar.

Le bureau Kalidro est produit d'une manière à conserver les ressources et est conçu pour durer. Dans sa construction, une attention spéciale a été accordée à une utilisation minimale de matériaux et à l'interchangeabilité de ses composants. Il est aussi recyclable jusqu'à 99 %.

La mesa Kalidro se elabora reduciendo el consumo de recursos y está concebida para que dure mucho tiempo. En su construcción se hizo hincapié en usar pocos materiales y en que sus componentes fueran intercambiables. Además, es reciclable en un 99 %.

La scrivania Kalidro viene prodotta con riguardo alle risorse ed è stata concepita per essere usata per molto tempo. Nel costruirla si è voluto fare particolare attenzione a un utilizzo ridotto di materiale e all'intercambiabilità dei suoi componenti. Inoltre è al 99 % riciclabile.

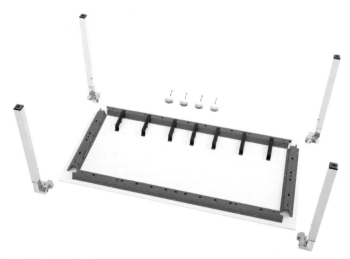

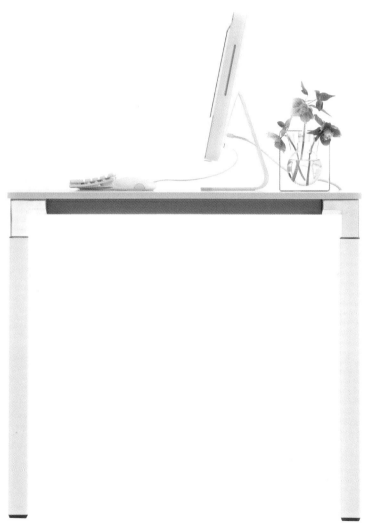

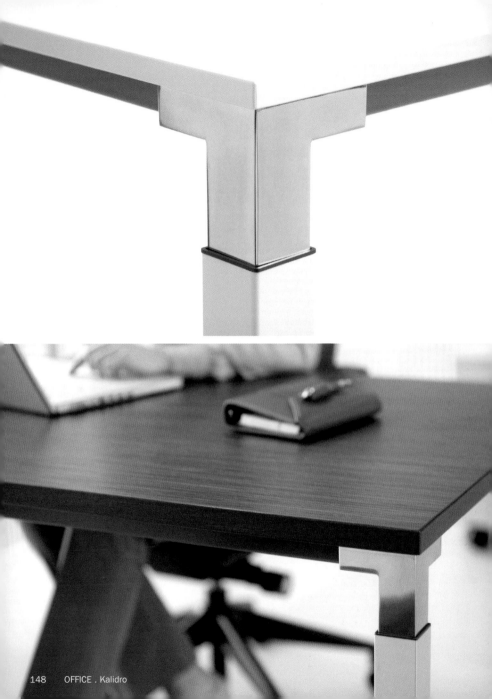

Leaf Task Light

Designer: Yves Behar/fuseproject
Manufacturer: Herman Miller, www.hermanmiller.com

The focus was on a minimization of energy consumption as well as a maximization of the possibilities for light in the development of this desk lamp. The individual adjustment of brightness and light color for the energy-efficient LEDs permits an ideal adaption to the home or office.

Eine Minimierung des Energieverbrauchs, sowie eine Maximierung der Lichtmöglichkeiten standen bei der Entwicklung dieser Schreibtischlampe im Vordergrund. Die individuelle Justierung von Helligkeit und Lichtfarbe der energieeffizienten LEDs erlaubt eine ideale Anpassung an Wohnung oder Büro.

Lors de la création de cette lampe de bureau, l'accent a été mis sur une minimisation du consommation d'énergie et une maximisation des possibilités d'éclairage. L'ajustement individuel de la clarté et de la couleur de ses lampes DEL économes en énergie permet une adaptation parfaite à la maison ou au bureau.

Minimizar el consumo de energía y maximizar la capacidad lumínica eran las principales premisas que marcaron el desarrollo de este flexo. El ajuste individualizado de la intensidad y del color de la luz de sus lámparas LED de gran eficiencia energética permite la perfecta adaptación a la vivienda o la oficina.

Nel realizzare questa lampada da tavolo si è voluto minimizzare il consumo di energia e massimizzare le possibilità di illuminazione. La regolazione manuale della luminosità e del colore della luce dei LED a basso consumo energetico consente un adattamento ideale all'appartamento o all'ufficio.

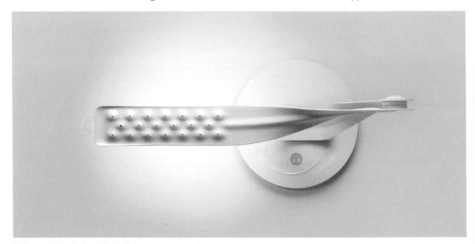

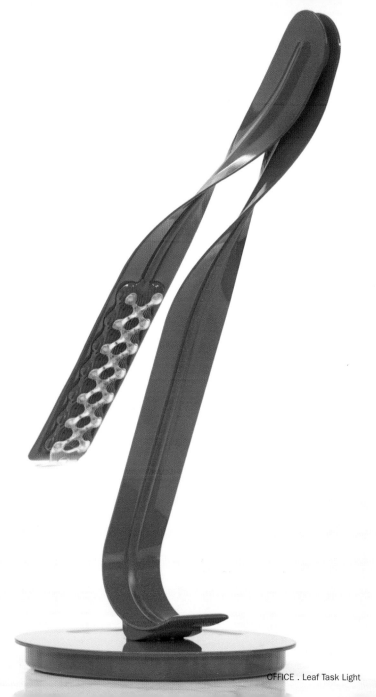

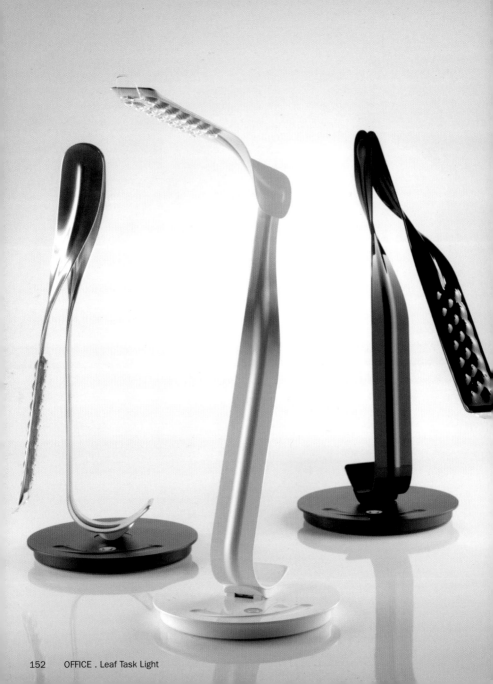

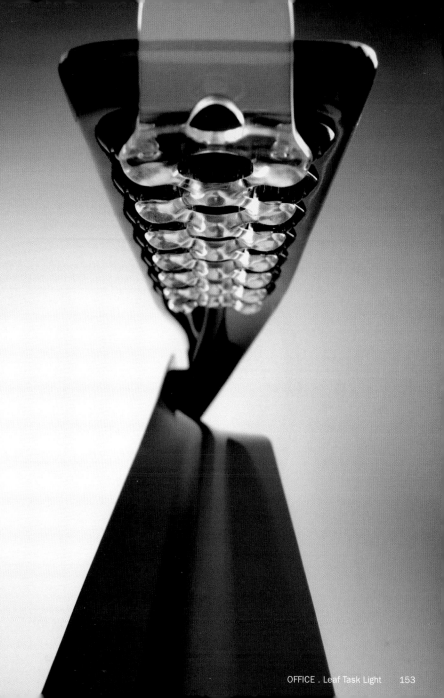

Paperbag

Designer: Jos van der Meulen
Manufacturer: Goods, www.goods.nl

Each of these wastepaper baskets is a unique item: Made of unused advertising posters or world maps, the colorful objects are stitched together. They are shipped in flat packaging and can be assembled by the owners. They have even made it into the collection of the Museum of Modern Art.

Jeder dieser Papierkörbe ist ein Unikat: Aus unbenutzten Werbeplakaten oder Weltkarten sind die farbenfrohen Objekte zusammengenäht. Sie werden flach verpackt ausgeliefert und können vom Besitzer selber in Form gebracht werden und haben es inzwischen sogar in die Sammlung des Museum of Modern Art geschafft.

Chacune de ces corbeilles à papier colorées est une pièce unique, fabriquée à partir d'affiches publicitaires ou de cartes inutilisées cousues. Elles sont livrées dans un emballage plat et assemblées par leurs propriétaires, et font même partie de la collection du Museum of Modern Art.

Cada una de estas papeleras es única. A partir de carteles publicitarios o mapamundis sin utilizar, se confeccionan estos objetos tan coloristas. Se sirven en paquetes planos y es el mismo propietario el que les da forma. Han conseguido incluso entrar a formar parte de la colección del Museum of Modern Art.

Ognuno di questi cestini è un unicum: sono stati creati cucendo insieme cartelloni pubblicitari o planisferi in oggetti colorati. Vengono consegnati confezionati piatti e possono essere formati dal proprietario stesso. Sono riusciti addirittura ad approdare alla collezione del Museum of Modern Art.

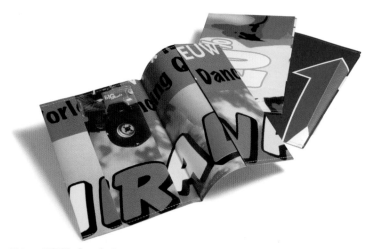

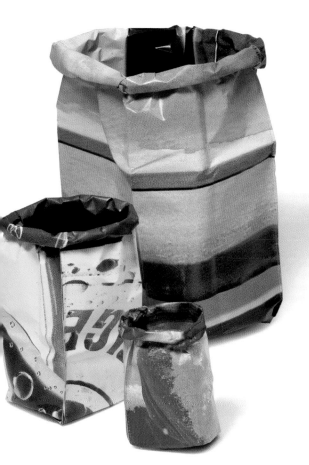
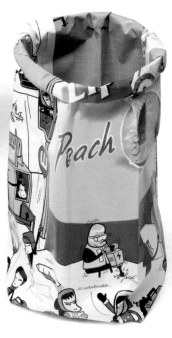

Think

Designer: Glen Oliver Löw
Manufacturer: Steelcase, www.steelcase.com

An important factor in the recycling of products is the quick disassembly. The Think office chair can be taken apart in just five minutes with simple tools—a worthwhile effort because 99 % of the chair (with a weight of just 33 pounds) can be recycled.

Ein wichtiger Faktor beim Recycling von Produkten ist die schnelle Demontage. Der Bürostuhl Think ist in nur fünf Minuten mit einfachem Werkzeug zu demontieren – ein lohnender Aufwand, denn 99 % des Stuhls (dessen Gewicht nur 15 Kilo beträgt) sind recycelbar.

Un facteur important dans le recyclage des produits est la rapidité de désassemblage. La chaise de bureau Think peut être démontée en seulement 5 minutes avec des outils simples : un effort qui en vaut la peine car la chaise (qui pèse seulement 15 kg) peut être recyclée à 99 %.

Un factor importante en el reciclado de productos es su rapidez a la hora de desmontarlos. La silla de oficina Think se desmonta en cinco minutos y con herramientas sencillas. El esfuerzo tiene su recompensa, pues el 99 % de esta silla de 15 kg de peso es reciclable.

Un importante fattore nel riciclaggio di prodotti è il veloce smontaggio. La sedia da ufficio Think è facile da smontare in soli cinque minuti con semplici attrezzi – e ne vale la pena, perché il 99 % della sedia (che pesa solo 15 chili) è riciclabile.

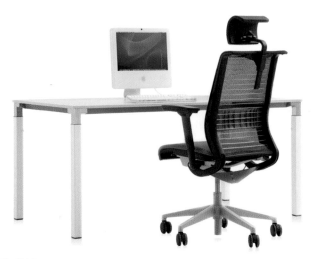

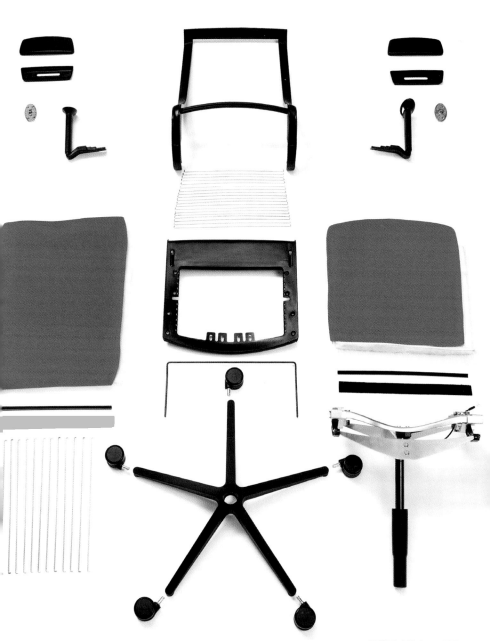

Eco-friendly Handbags

Designer: Helen E Riegle
Manufacturer: Helen E Riegle, www.her-design.com

A special focus was on the selection of ecological raw materials in the manufacture of these handbags inspired by floral shapes. Cotton from ecological cultivation, rubber, hemp fabric, and wool are included in the materials, as well as recycled PET and PVC-free leather.

Bei der Herstellung dieser durch Blumenformen inspirierten Handtaschen wurde besonders auf die Auswahl ökologischer Rohstoffe geachtet. Baumwolle aus ökologischem Anbau, Kautschuk, Hanfgewebe und Wolle gehören ebenso zu den eingesetzten Materialien wie recyceltes PET und PVC-freies Leder.

L'emphase été mise sur le choix de matières premières écologiques pour la fabrication de ces sacs à main inspirés des formes florales. On retrouve parmi leurs matériaux du coton issu de culture écologique, du caoutchouc, du chanvre et de la laine, ainsi que du PET recyclé et du cuir sans PVC.

En la elaboración de estos bolsos con líneas inspiradas en las formas de las flores se dio preponderancia a las materias primas ecológicas. Algodón de plantaciones sostenibles, caucho, tela de cáñamo y lana son algunos de los materiales empleados, además de PET reciclado o cuero libre de PVC.

Nel produrre queste borsette ispirate alle forme dei fiori, si è voluto porre particolarmente l'accento sulla scelta delle materie prime ecologiche. Il cotone di coltivazione biologica, il caucciù, la canapa e la lana fanno parte dei materiali utilizzati come il PET riciclato e il cuoio senza PVC.

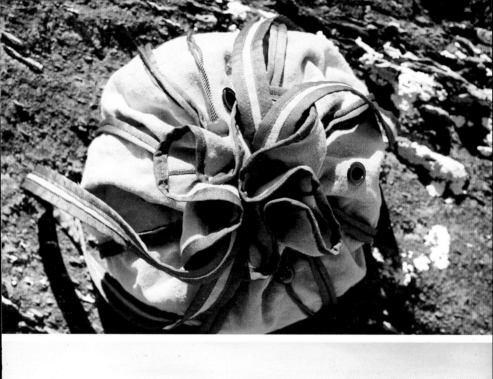

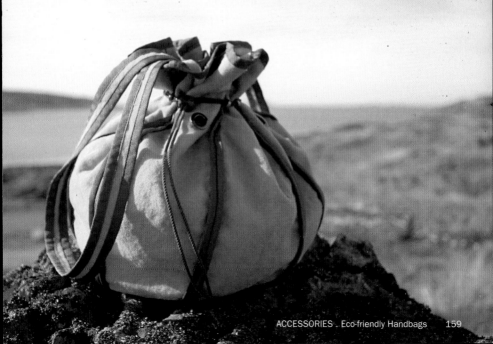

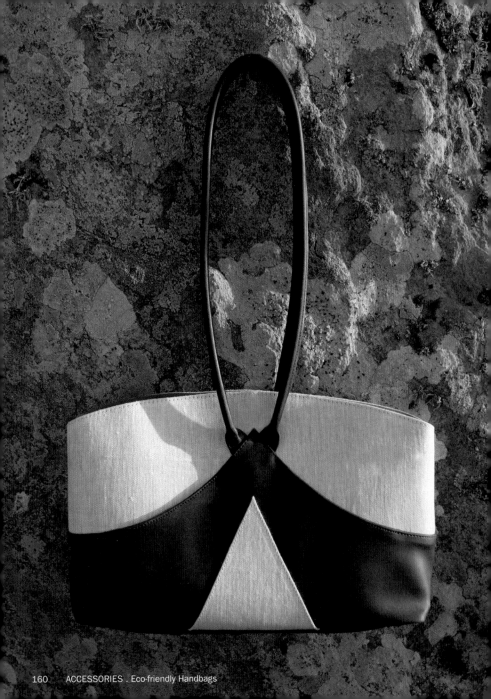

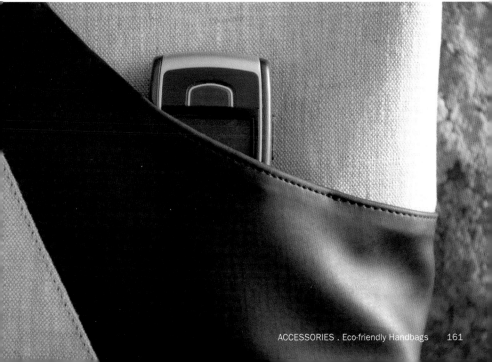

Noon Solar Bags

Designer: noon solar
Manufacturer: noon solar, www.noonsolar.com

Combining ecology with style is the goal of this bag manufacturer. The products are sustainably produced and also have built-in solar panels that charge an integrated battery. This can transmit energy to a cell phone or an MP3 player at any time.

Ökologie mit Mode zu verbinden ist das Ziel dieses Taschenherstellers. Die Produkte sind nachhaltig produziert und besitzen zudem eingebaute Solar-Paneele, die einen integrierten Akku aufladen. Dieser kann die Energie dann jederzeit an ein Handy oder einen MP3-Spieler weitergeben.

Ce fabricant de sacs a pour objectif d'allier écologie et style. Ses sacs sont produits de manière durable et comportent également des panneaux solaires permettant de charger une batterie intégrée. Elle peut à tout moment transmettre du courant à un téléphone portable ou à un lecteur MP3.

Aunar ecología y estilo es el objetivo de este fabricante de bolsos. Los productos se fabrican siguiendo principios de sostenibilidad y cuentan además con paneles solares que sirven para cargar una batería integrada, que pueden volcar la energía acumulada en un móvil o un reproductor de MP3.

Lo scopo di questo produttore di borse è di unire l'ecologia con il design. I prodotti sono duraturi e possiedono un pannello solare che ricarica la batteria integrata. Quest'ultima può poi dare energia al cellulare o al lettore MP3, in qualsiasi momento.

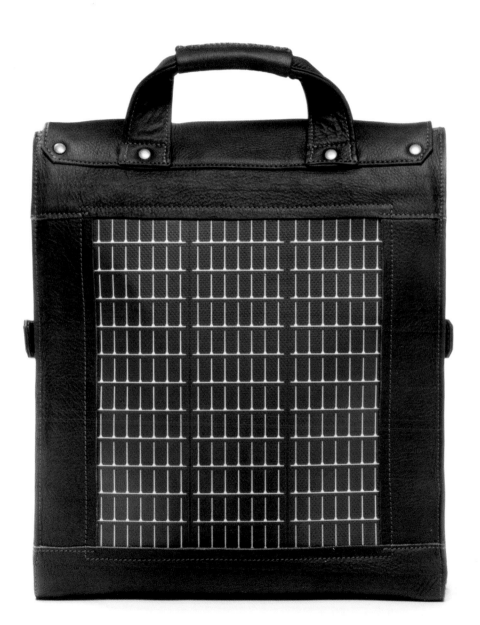

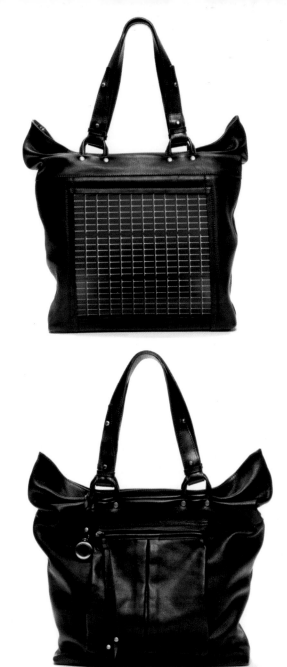

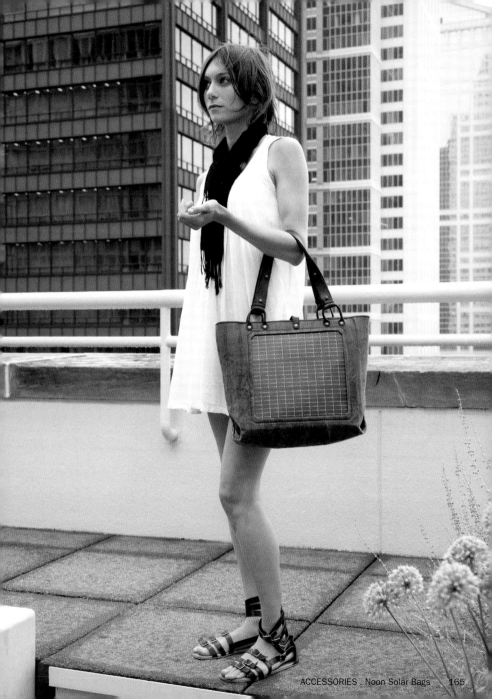

Oak Leaf Modular System

Designer: Mary-Ann Williams
Manufacturer: ILLU STRATION, www.illu-stration.de

Designer Mary-Ann Williams developed these objects from woolen felt. She combines the stamped two-dimensional oak leaves into three-dimensional objects such as rugs and lampshades. If necessary (when soiled, for example), the leaves can be replaced individually.

Die Designerin Mary-Ann Williams entwickelte diese Objekte aus Wollfilz. Sie verbindet die gestanzten zweidimensionalen Eichenblätter zu dreidimensionalen Objekten wie Teppichen und Lampenschirmen. Die Blätter können bei Bedarf (etwa Verschmutzung) einzeln ausgetauscht werden.

Mary-Ann Williams, designer, a créé ces objets en feutre de laine. Elle associe des feuilles de chêne tamponnées bidimensionnelles dans des objets tridimensionnels comme des tapis et des abat-jour. Les feuilles peuvent être remplacées une par une si besoin, quand elles sont sales notamment.

La diseñadora Mary-Ann Williams concibió estos objetos de fieltro de lana. Las hojas de roble bidimensionales troqueladas se engarzan para formar objetos tridimensionales tales como alfombras o pantallas. En caso de necesidad (por ejemplo, si se ensucia), puede sustituirse la hoja afectada.

La designer Mary-Ann Williams ha sviluppato questi oggetti di feltro di lana. Unisce le foglie di quercia bidimensionali stampate per farne oggetti tridimensionali come tappeti e paralumi. Le foglie possono essere sostituite singolarmente in caso di necessità (per esempio se si sporcano).

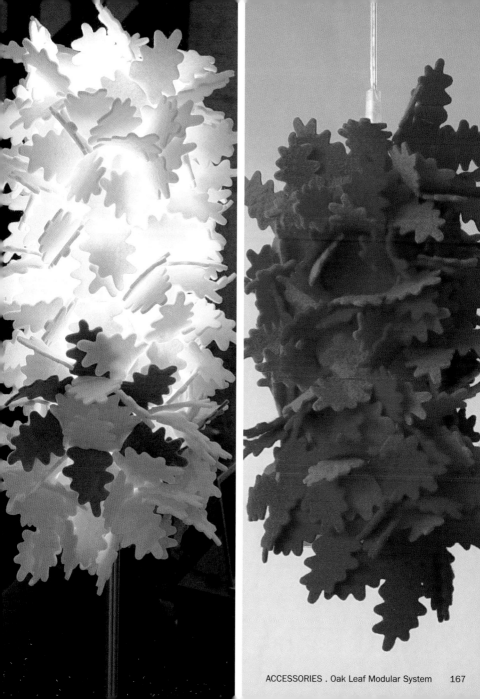

Revolve UK

Designer: Revolve
Manufacturer: Revolve, www.revolve-uk.com

Electrical appliances frequently just have a short life and are replaced quickly by the next generation. As a result, the British manufacturer Revolve uses printed circuit boards, old CDs, and recycling plastics that have been disposed of as decorative components for its products.

Elektrogeräte haben oft nur eine kurze Lebensdauer, dann werden sie von der nächsten Generation abgelöst. Der britische Hersteller Revolve verwendet daher entsorgte Platinen, alte CDs und Recyclingkunststoff als schmückende Bestandteile für seine Produkte.

Les appareils électriques ont souvent une vie courte et sont rapidement remplacés par la nouvelle génération. C'est pourquoi le fabricant britannique Revolve utilise des cartes de circuits imprimés, de vieux CD et des plastiques recyclables qui ont été jetés pour décorer ses produits.

Los aparatos eléctricos suelen disfrutar de una corta existencia al ser sustituidos por la siguiente generación. El fabricante inglés Revolve utiliza viejas placas base, discos compactos y plásticos reciclados como elementos decorativos de sus productos.

Gli elettrodomestici hanno spesso una breve durata, poi vengono sostituiti dalla generazione successiva. Il produttore britannico Revolve utilizza quindi delle piastrine smaltite, vecchi CD e plastica riciclabile come elementi decorativi dei suoi prodotti.

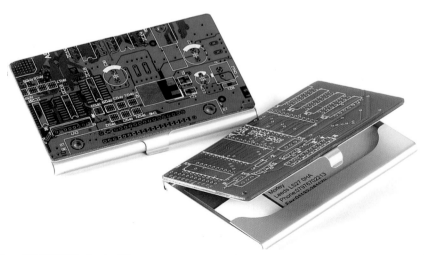

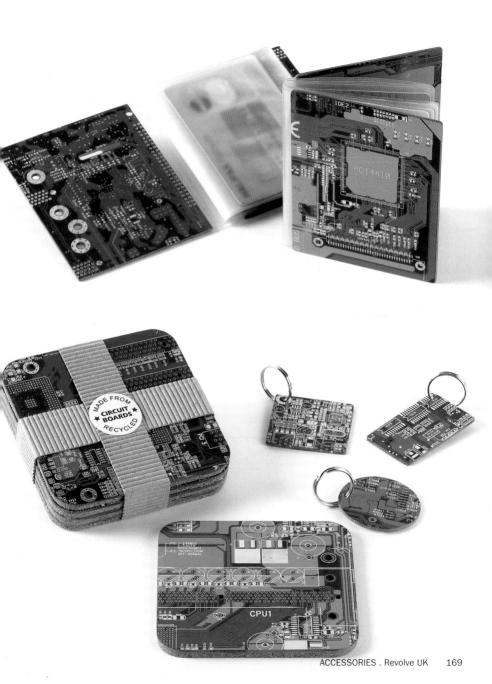

MADE FROM CIRCUIT BOARDS RECYCLED

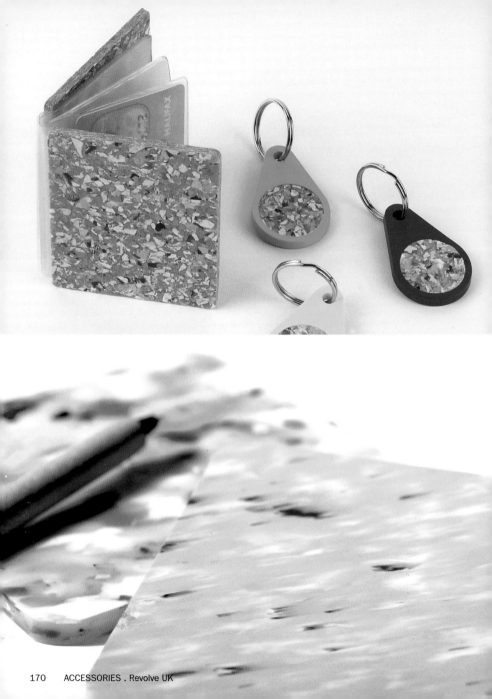

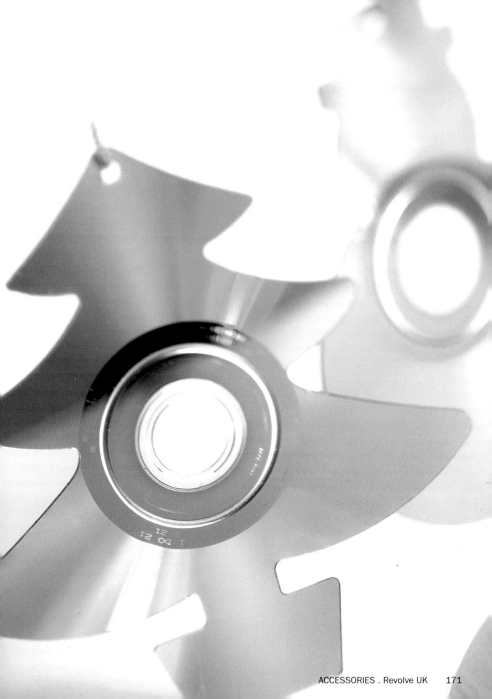

Spielerfrauenkollektion

Designer: Dunja Karabaic
Manufacturer: Rcyclia, www.rcyclia.de

This jewelry collection made of recycling material was inspired by the national flags as they are presented at an event like the World Cup. The designer has abstracted and combined them with stereotypical attributes of the respective country in one piece of jewelry.

Diese Schmuckkollektion aus Recyclingmaterial ist inspiriert von Nationalflaggen, wie sie etwa bei einer Fußball-WM präsentiert werden. Die Designerin hat diese abstrahiert und mit klischeehaften Attributen des jeweiligen Landes kombiniert in ein Schmuckstück übertragen.

Cette collection de joaillerie en matériaux recyclables tire son inspiration des drapeaux nationaux comme ils sont présentés lors d'un événement international tel que la Coupe du Monde. La designer les a rendus abstraits et associés avec les stéréotypes de chaque pays dans un bijou.

Esta colección de bisutería a base de materiales reciclados se inspira en las banderas nacionales, tal y como se presentarían, por ejemplo, en un mundial de fútbol. La diseñadora las ha abstraído y combinado con atributos estereotipados de cada país y las ha plasmado en una pieza de bisutería.

Questa collezione di gioielli di materiale riciclabile è stata ispirata dalle bandiere nazionali, come vengono presentate per esempio in un campionato mondiale di calcio. La designer le ha estraniate e combinate con attributi stereotipati di ogni paese, per trasportarli in un gioiello.

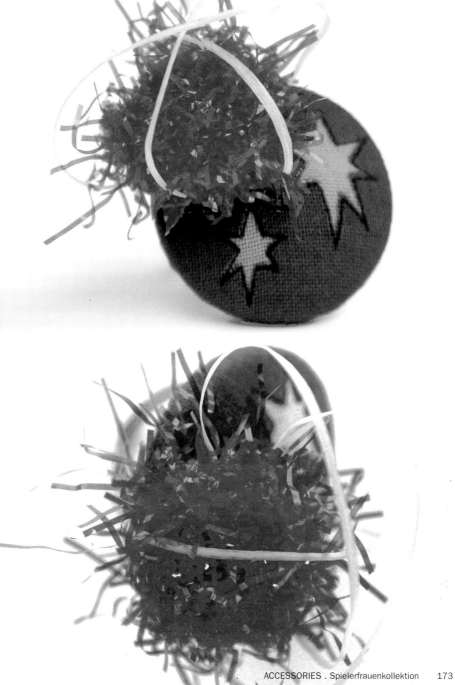

`Stoff wichtig!`

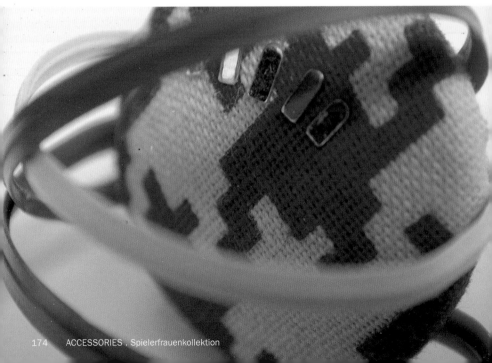

um bags

Designer: Josh Jakus
Manufacturer: Josh Jakus, www.joshjakus.com

Instead of landing in the trash bin, excess wool fiber is pressed into industrial felt and used in these round um bags. Through a special zipper connection between two layers of the natural material, they have been transformed into original bags in a variety of sizes.

Anstatt im Abfallcontainer zu landen, wird aus überschüssigen Wollfasern industrieller Wollfilz gepresst und daraus die runden um bags hergestellt. Durch eine spezielle Reisverschluss-Verbindung werden zwei Lagen des natürlichen Materials in originelle Taschen verschiedenster Größe verwandelt.

Au lieu d'atterrir dans la poubelle, l'industriels de feutre de laine sont transformés pour devenir ces sacs um bags tout ronds. Grâce à une fermeture à zip spéciale, deux morceaux de cette matière naturelle forment un de ces sacs originaux et disponibles en plusieurs tailles.

En lugar de acabar en el cubo de la basura, con el fieltro de lana industrial se confeccionan las um bags, de forma esferoidal. Unidas por una cremallera especial, dos piezas de este material natural se transforman en unos originales bolsos en diferentes tamaños.

Invece di finire nel secchio dei rifiuti, el feltro di lana industriale vengono prodotti gli um bags. Grazie a speciali cerniere a lampo, due strati del materiale naturale vengono trasformati in borse originali delle più svariate misure.

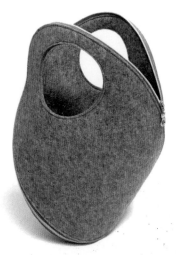

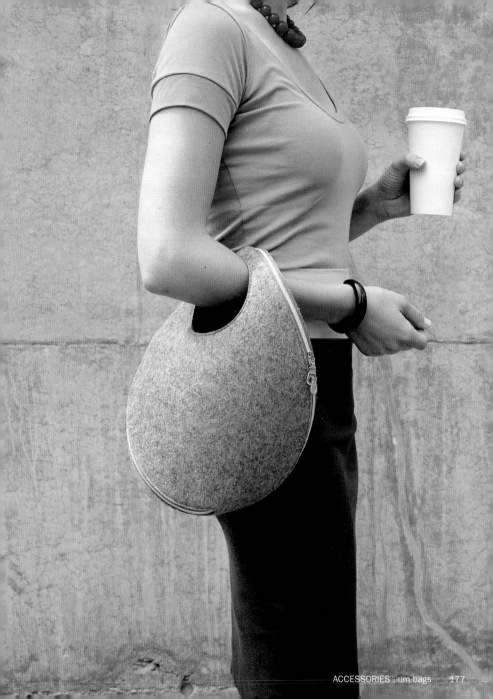

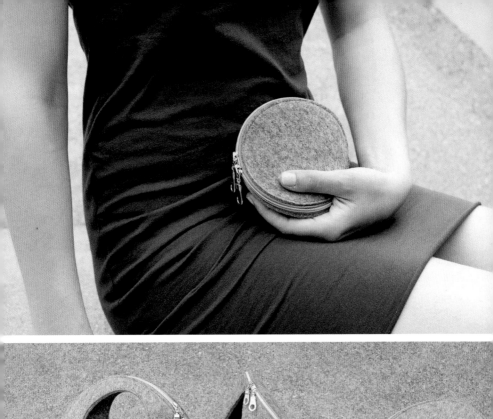

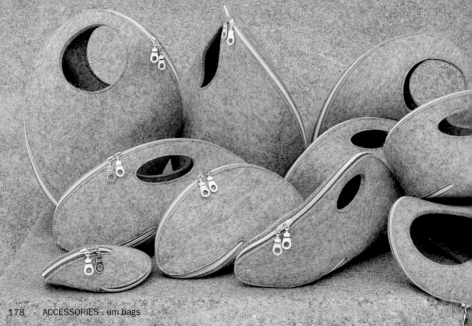

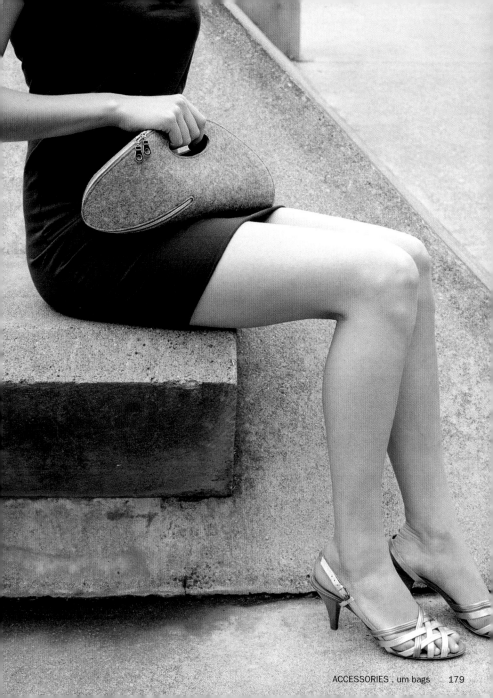

Wheels-on-Fire Collection

Designer: Jan Willem van Breugel
Manufacturer: Wheels-on-Fire, www.wheels-on-fire.nl

Almost everyone in the Netherlands rides a bike. A corresponding number of bicycles exists there, which ultimately also require disposal. The designer Jan Willem van Breugel likes to use these and transform old bicycle inner tubes into bags, armchairs, and tables. The rims become chandeliers.

Nahezu jeder Niederländer ist mit dem Rad unterwegs, entsprechend viele Fahrräder existieren dort und müssen schließlich auch entsorgt werden. Der Designer Jan Willem van Breugel übernimmt dies gerne und verwandelt alte Fahrradschläuche in Taschen, Sessel und Tische und Felgen in Kronleuchter.

Presque tout le monde aux Pays-Bas fait du vélo, et il y a donc un grand nombre de bicyclettes, qu'il faut bien finir par jeter. Le designer Jan Willem van Breugel aime utiliser ces vieux vélos et transformer les chambres à air en sacs, fauteuils et tables, et les jantes en lustres.

Prácticamente todos los holandeses se desplazan en bicicleta, por lo que en este país son muchísimas las que hay, y que al final habrá que retirar de forma respetuosa con el medio. El diseñador Jan Willem van Breugel se encarga de ello transformando viejas cámaras en bolsos, sillones o mesillas, y las llantas en lucernas.

Praticamente tutti gli olandesi si muovono su due ruote, quindi ci sono molte biciclette e devono essere successivamente smaltite. Il designer Jan Willem van Breugel se ne è fatto carico volentieri e trasforma vecchie camere d'aria di biciclette in borse, sedie e tavoli, e i cerchioni in lampadari.

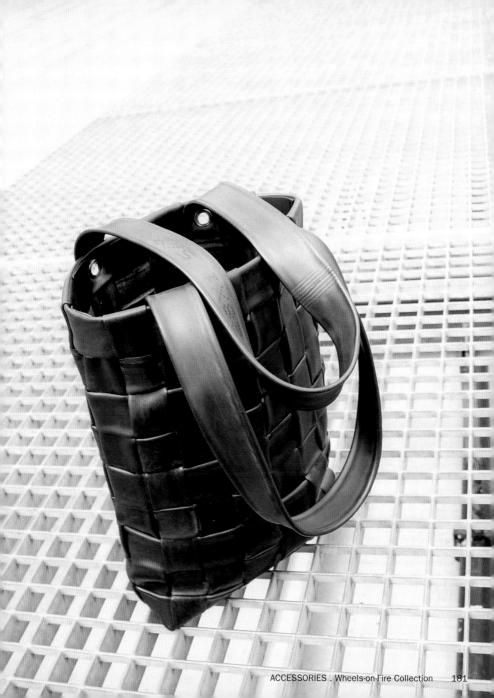

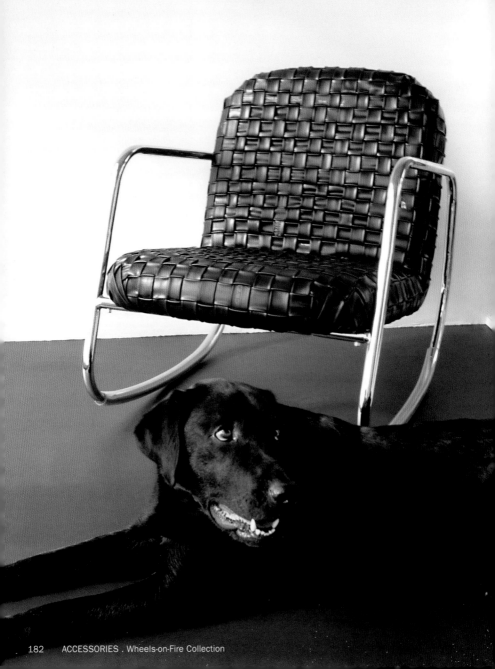

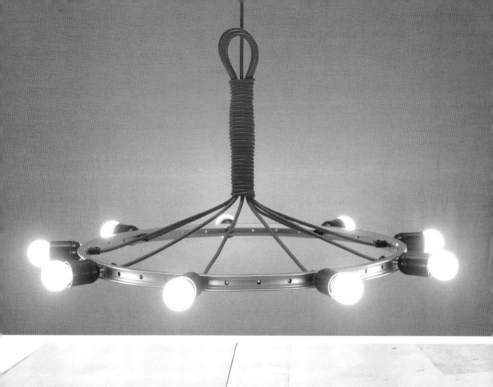

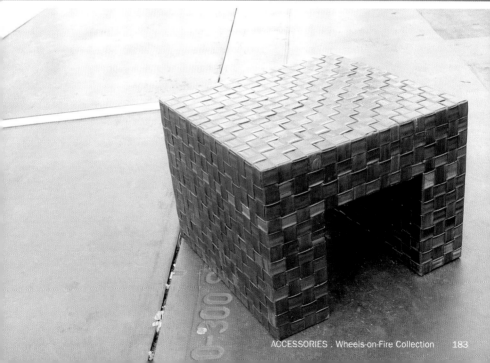

Astrolab

Designer: Sacha Lakic
Manufacturer: Venturi, www.venturi.fr

The sitting position and construction of this car are modeled on a Formula 1 racecar, but not the drive. This is exclusively electric, and the rechargeable battery lasts for up to 68 miles. The batteries are charged through the extensive solar cells or an outlet.

Die Sitzposition und die Konstruktion dieses Wagens sind an einen Formel-1-Renner angelehnt, nicht jedoch der Antrieb. Dieser ist ausschließlich elektrisch, der Akku reicht bis zu 110 km. Die Aufladung der Batterien erfolgt über die großflächigen Solarzellen oder eine Steckdose.

La position assise et la structure de cette voiture s'inspirent des bolides de Formule 1, mais pas sa conduite. Elle est exclusivement électrique, et sa batterie rechargeable permet de faire jusqu'à 110 km. Les batteries se chargent via les grands panneaux solaires ou sur une prise.

La posición de los asientos y la construcción de este vehículo se han inspirado en las de un fórmula 1, no así su propulsión, que en este caso es únicamente eléctrica. La batería tiene una autonomía de 110 km. De recargarla se encargan los grandes paneles solares o se conecta el coche a un enchufe.

La posizione del sedile e la costruzione di questa vettura si rifà a un'auto da Formula 1, ma non il comando. Quest'ultimo è esclusivamente elettrico, la batteria basta per arrivare a 110 km. La ricarica delle batterie avviene tramite ampie cellule solari o attaccandole alla presa elettrica.

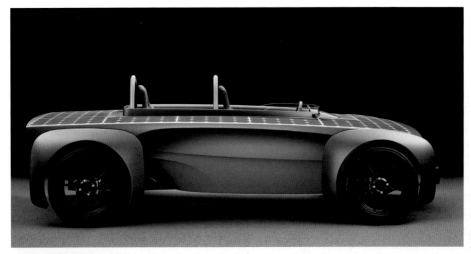

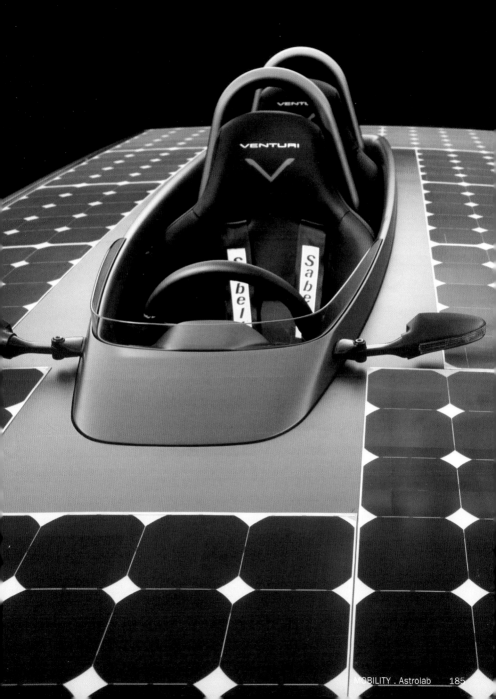

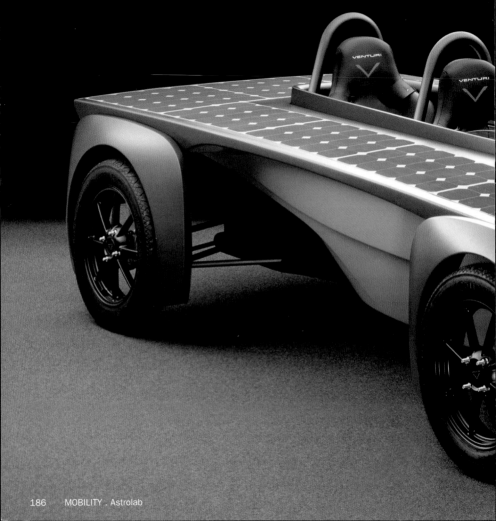

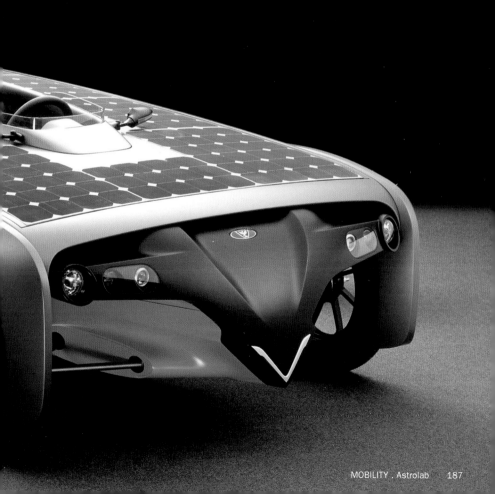

bikedispenser.com

Designer: Marcel Schreuder, John Kock, Hans Schreuder, Frank Rettenbacher, Anton Brunt, Maurits Homan
Manufacturer: Springtime, www.springtime.nl / Bikedispenser, www.bikedispenser.com

Instead of drinks or snacks, this vending machine spits out entire bicycles. The service is available to registered users for purposes like covering the remaining yards from the subway station to the office. This closes the last gap in the transportation chain.

Dieser Automat spuckt nicht etwa Getränke oder Snacks aus, sondern ganze Fahrräder. Ein Service, der für registrierte Nutzer zur Verfügung steht, um etwa die restlichen Meter von der U-Bahnstation zum Büro zu bewältigen. So wird die letzte Lücke in der Transportkette geschlossen.

Plutôt que des boissons ou des chips, cette machine distribue des vélos entiers. Le service est disponible pour les utilisateurs inscrits, notamment pour parcourir les derniers mètres de la station de métro au bureau. C'est le dernier maillon de la chaîne de transport.

Esta máquina no sirve ni bebidas ni ningún refrigerio, sino bicicletas con todas sus piezas. Para disfrutar de este servicio, que permite cubrir la distancia entre la estación de metro y la oficina, hay que estar registrado. De esta forma, no queda ningún eslabón suelto en la cadena de transporte.

Questo distributore non tira fuori bevande o snack ma vere e proprie biciclette. Un servizio messo a disposizione agli utenti registrati, per superare i restanti metri dalla metropolitana all'ufficio. Così l'ultima lacuna della catena di trasporto viene colmata.

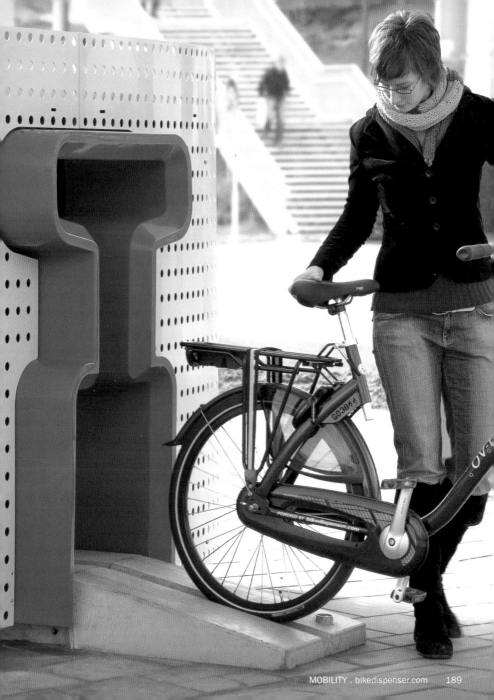

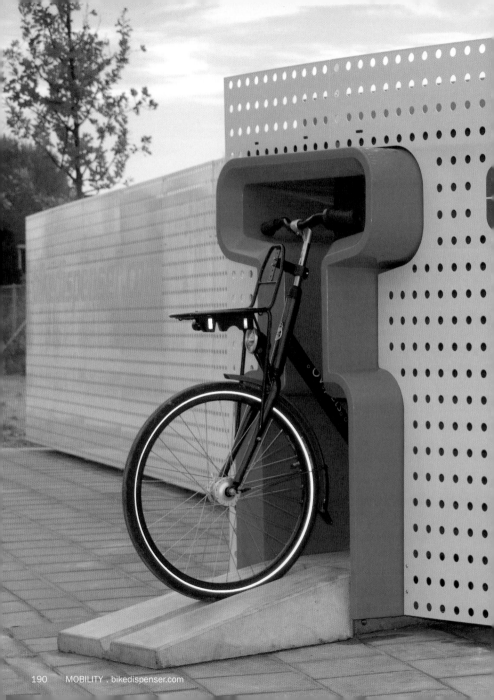

CLEVER – Compact Low Emission Vehicle for Urban Transport

Designer: naumann-design
Manufacturer: Prototype, www.bmwgroup.com, www.clever-project.net

The goal of this project: Two people should be about to ride 62 miles for one euro worth of fuel. This is realized through a two-seat three wheeler with tilting technology and gas drive. Thanks to the aluminum spaceframe, the vehicle is reportedly even safer than a small car.

Das Ziel des Projekts: Für einen Euro Treibstoff sollen zwei Personen 100 km weit fahren können. Realisiert wurde dies durch ein zweisitziges Dreirad mit Neigetechnologie und Gasantrieb. Dank Aluminium-Spaceframe soll das Fahrzeug sogar so sicher sein wie ein Kleinwagen.

L'objectif de ce projet : faire 100 km à deux personnes pour un euro de combustible. Cela est possible grâce à un tricycle à deux places avec un dispositif de basculement et une propulsion au gaz. Grâce à son cadre en aluminium, le véhicule serait même plus sûr qu'une petite voiture.

El objetivo de este proyecto fue que con un euro de combustible, dos personas cubran 100 km. Se pudo conseguir con este triciclo biplaza con tecnología basculante y propulsión a gas natural. Gracias a su estructura de aluminio, este vehículo llega a ser tan seguro como cualquier utilitario.

Scopo del progetto: con un euro di carburante due persone devono poter percorrere 100 km. Ed è stato realizzato tramite un triciclo a due posti con tecnologia a pendolino e con motore a gas. Grazie allo spaceframe in alluminio la vettura è sicura addirittura come un'utilitaria.

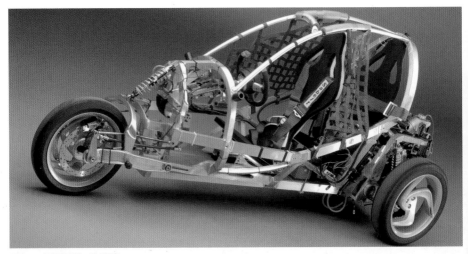

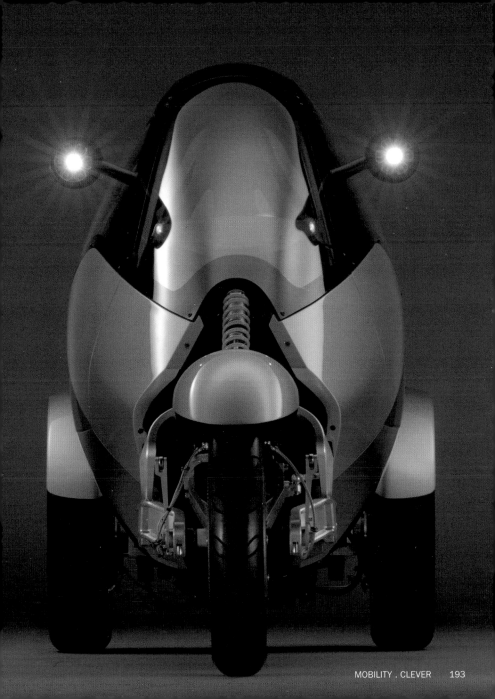

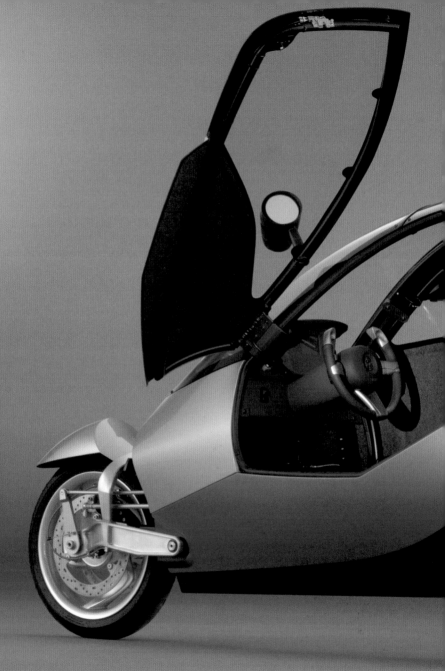

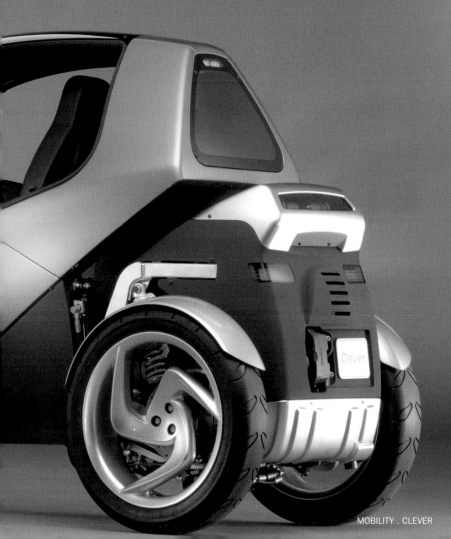

Clever

Eclectic

Designer: Sacha Lakic
Manufacturer: Venturi, www.venturi.fr

Independent of gas stations and fossil fuels, the Venturi Eclectic is powered solely through its own energy production. The three-seat electric vehicle is driven by solar or wind energy. But, in case of an emergency, an outlet can also be used.

Unabhängig von Tankstellen und fossilen Brennstoffen wird der Venturi Eclectic ausschließlich aus eigener Energieproduktion angetrieben. Solar- oder Windenergie versorgen das dreisitzige Elektrofahrzeug – im Notfall kann jedoch auch eine Steckdose angezapft werden.

Indépendant des stations service et des énergies fossiles, le Venturi Eclectic est propulsé seulement par sa propre production d'énergie. Ce véhicule électrique à trois places fonctionne à l'énergie solaire ou éolienne, mais en cas d'urgence, il peut aussi être branché sur une prise.

Únicamente su propia energía impulsa al Venturi Eclectic, que puede prescindir así de gasolineras y de combustibles fósiles. Este vehículo eléctrico de tres plazas se surte con energía solar y eólica. En caso de emergencia, se le puede conectar a un enchufe.

E' indipendente da stazioni di rifornimento e dai combustibili fossili, perché la Venturi Eclectic viene azionata unicamente da una produzione propria di energia. L'energia solare o eolica alimenta il veicolo elettrico a tre posti – ma in caso d'emergenza la si può attaccare a una presa elettrica.

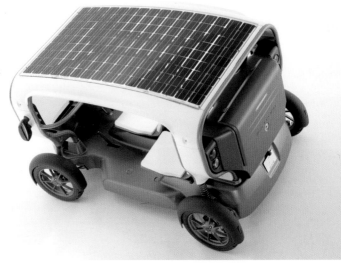

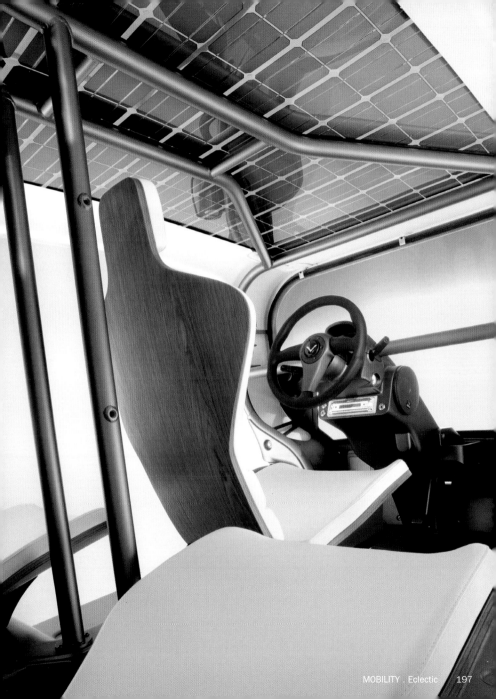

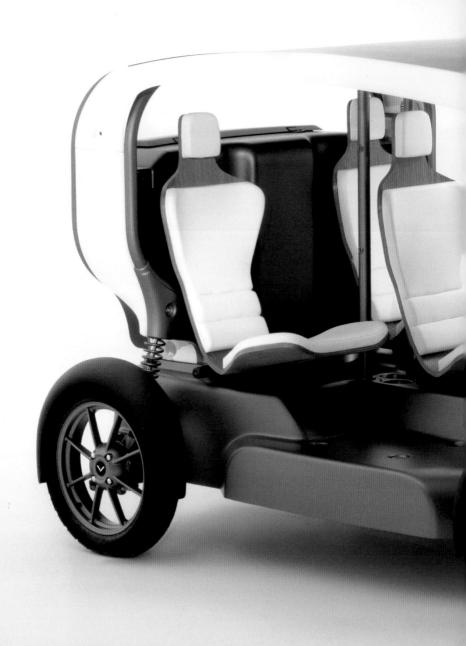

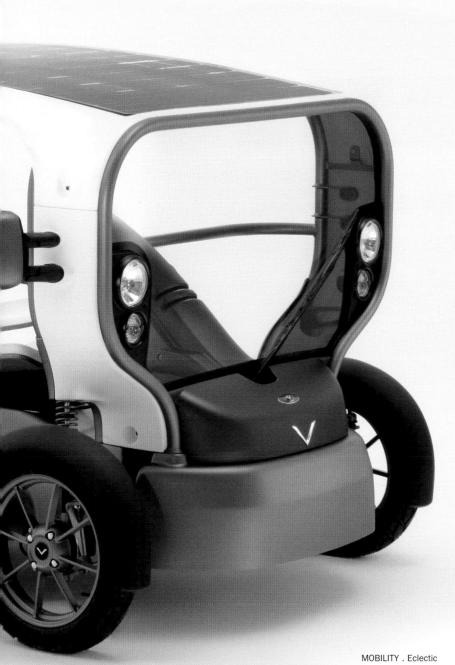

Feetz

Designer: Lennart Vissers
Manufacturer: Herbert Vissers, www.feetz.nl

Not a bicycle but a multi-talent: The three-wheel vehicle can transport loads, as well as children. It tilts in the curves and, when necessary, can even be folded. This makes it easy to transport or push like a stroller.

Kein Fahrrad, ein Multitalent: Mit dem dreirädrigen Gefährt lassen sich Lasten ebenso transportieren wie Kinder, in den Kurven neigt es sich und wenn nötig ist es sogar zusammenklappbar. So lässt es sich leicht transportieren oder wie ein Kinderwagen schieben.

Pas un vélo mais une somme de talents : le tricycle peut transporter des charges ainsi que des enfants. Il s'incline dans les courbes et peut être plié si nécessaire. Cela le rend facile à transporter ou à pousser.

No es una bicicleta, sino un multitalento: en este vehículo de tres ruedas se pueden llevar bultos o también niños. Bascula al tomar las curvas. Si es necesario, se puede plegar. Es fácil de transportar y se puede llevar como un cochecito de bebé.

Non una bicicletta ma un multitalento: con questo veicolo a tre ruote si possono trasportare carichi e anche i bambini, si piega in curva e, se necessario, è pure pieghevole. Così è facile da trasportare o lo si può spingere come un passeggino.

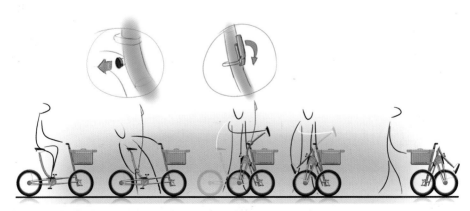

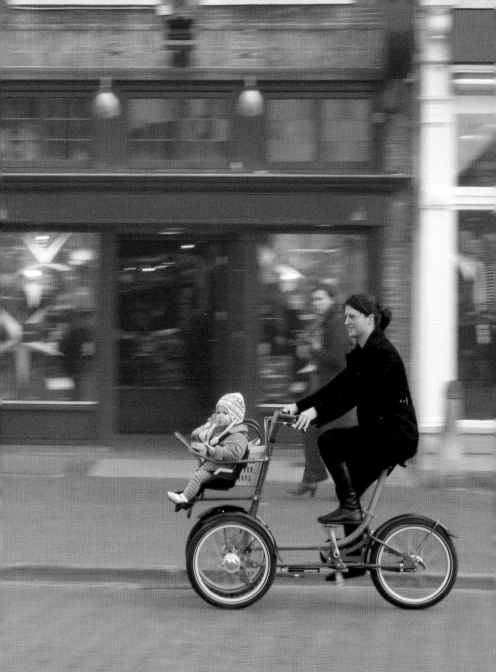

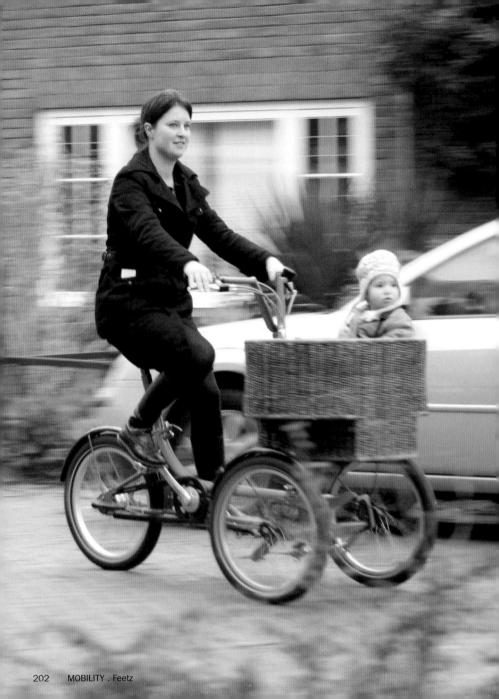

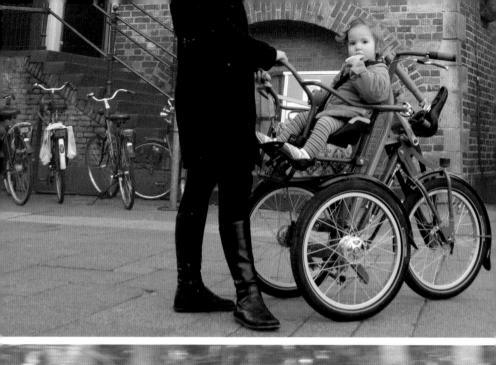

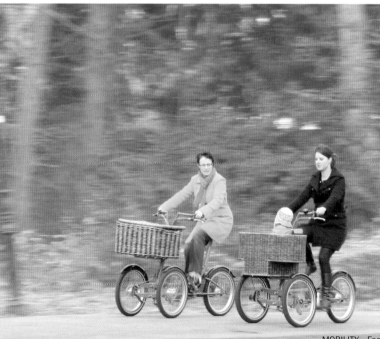

Fétish

Designer: Sacha Lakic
Manufacturer: Venturi, www.venturi.fr

Can an electric car impart the same driving fun as a sports car with a combustion engine? The Monaco based manufacturer Venturi would like to offer proof that it's possible—the look and an acceleration of less than five seconds from 0 to 60 mph speak for themselves.

Kann ein Elektroauto den gleichen Fahrspaß vermitteln wie ein Sportwagen mit Verbrennungs-motor? Der monegassische Hersteller Venturi möchte mit dem Fétish den Beweis antreten – die Optik und eine Beschleunigung von unter fünf Sekunden von 0 auf 100 km/h sprechen für sich.

Une voiture électrique peut-elle être aussi agréable à conduire qu'une voiture de sport avec mo-teur à combustion ? Le constructeur monégasque Venturi aimerait prouver que c'est possible – le look et l'accélération de 0 à 100 km/h en moins de 5 secondes parlent d'eux-mêmes.

Un deportivo eléctrico, ¿puede llegar a producir el mismo placer al volante que uno de explo-sión? Venturi, el fabricante de Mónaco, ha querido confirmarlo con el Fétish. Su línea y su acele-ración, que lo lleva de 0 a 100 km/h en menos de cinco segundos, hablan por sí solas.

Può una macchina elettrica trasmettere lo stesso piacere di guidare di un'auto sportiva con motore a scoppio? Il produttore basato Monaco Venturi lo vorrebbe dimostrare con la Fétish – l'ottica e un'accelerazione di meno di cinque secondi da 0 a 100 km/h parlano per sé.

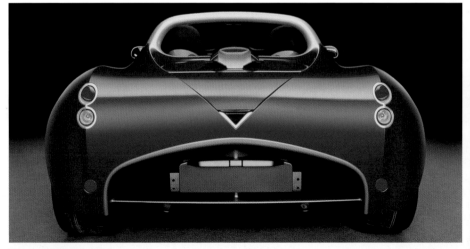

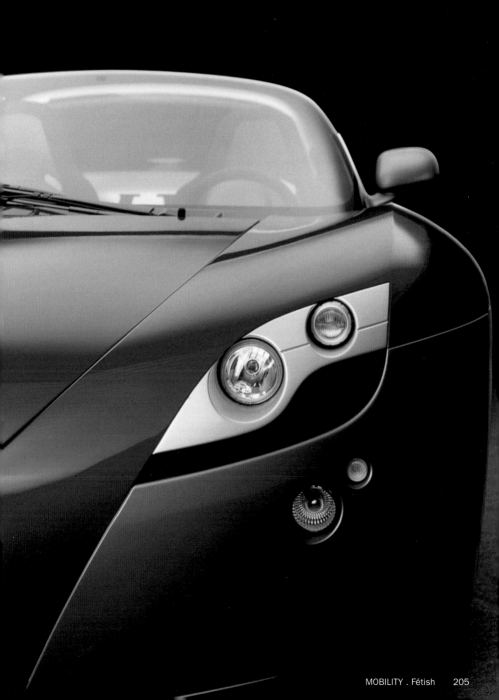

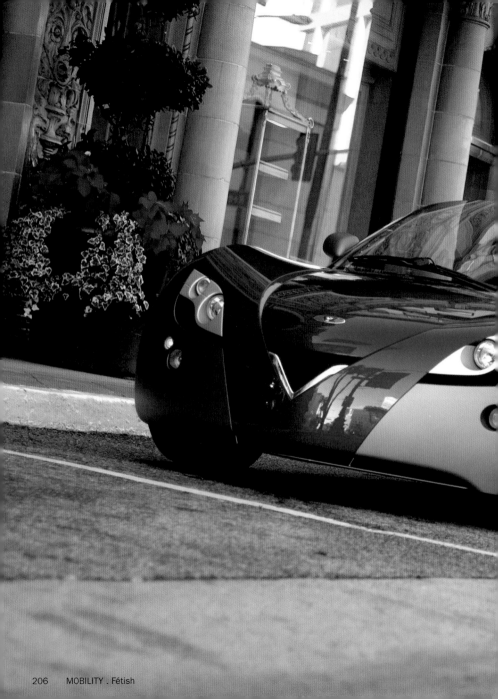

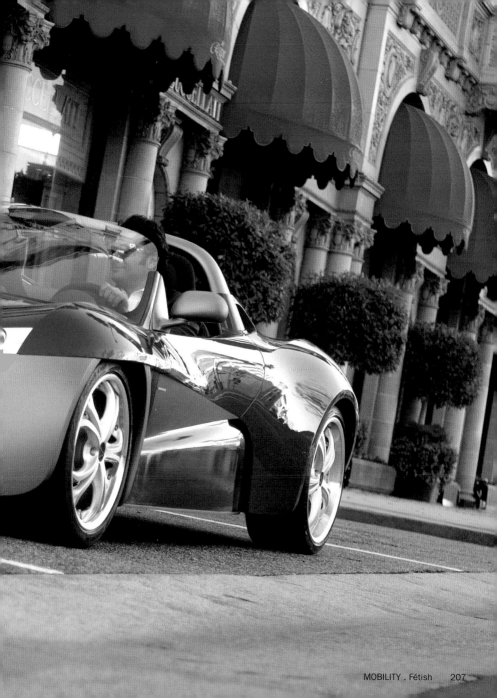

Jano Dual Bike

Designer: Roland Kaufmann (supported by GP designpartners gmbh)
Manufacturer: Prototype, http://gp.co.at/works/jano

The Jano Dual Bike is intended as a bicycle for everyday and other versatile uses. Its special feature is the frame of laminated wood that has an astonishing stiffness in this construction and can also carry small luggage.

Ein Fahrrad für den alltäglichen und vielseitigen Einsatz soll das Jano Dual Bike sein. Das Besondere ist der Rahmen aus schichtverleimtem Holz, der in dieser Konstruktion eine erstaunliche Steifigkeit aufweist und zudem kleines Gepäck aufnehmen kann.

Le Jano Dual Bike est conçu pour l'usage quotidien et pour d'autres utilisations. Ce qui le distingue est son cadre de bois lamellé d'une rigidité surprenante dans sa construction et il peut aussi transporter de petits bagages.

La Jano Dual Bike pretende ser una bicicleta de diario con infinidad de aplicaciones. Lo que más destaca de ella es su cuadro de madera multicapa que, en este producto, muestra una firmeza asombrosa. Permite asimismo transportar equipaje de reducido tamaño.

La Jano Dual Bike rappresenta la bicicletta per l'utilizzo quotidiano e molteplice. La particolarità è il telaio in legno multistrato, che dimostra in questa costruzione una rigidezza incredibile e inoltre può farsi carico di un piccolo bagaglio.

RoodRunner

Designer: Sjoerd Hoyink, Frank Mahn, Jorrit Schoonhoven
Manufacturer: Springtime, www.springtime.nl

The RoodRunner is a special vehicle that makes mail delivery faster and easier. Its special focus is on the ergonomics: The steering is smooth because it doesn't move the transportation box. In addition, it has a supporting electric drive.

Der RoodRunner ist ein Spezialfahrzeug, das die Briefzustellung schneller und leichter macht. Ein besonderer Fokus liegt auf der Ergonomie: Die Lenkung ist leichtgängig, da die Transportbox nicht mitbewegt wird, zudem gibt es einen unterstützenden Elektroantrieb.

Le RoodRunner est un véhicule spécial qui rend la distribution du courrier plus rapide et plus facile. Il met l'accent sur l'ergonomie : la direction est souple parce que la boîte de transport ne bouge pas. En outre, il dispose de commandes d'assistance électriques.

El RoodRunner es un vehículo especial con el que el reparto del correo se realiza con más rapidez y comodidad. Destaca en él su ergonomía. Es muy manejable, ya que al girar, la caja de carga no vira con el vehículo. Cuenta además con un motor eléctrico de apoyo.

Il RoodRunner è un veicolo specializzato che velocizza ed esemplifica la consegna della posta. Un punto focale particolare è l'ergonomia: Lo sterzo è leggero, visto che la scatola di trasporto non viene mossa anche essa, inoltre c'è un motore elettrico di supporto.

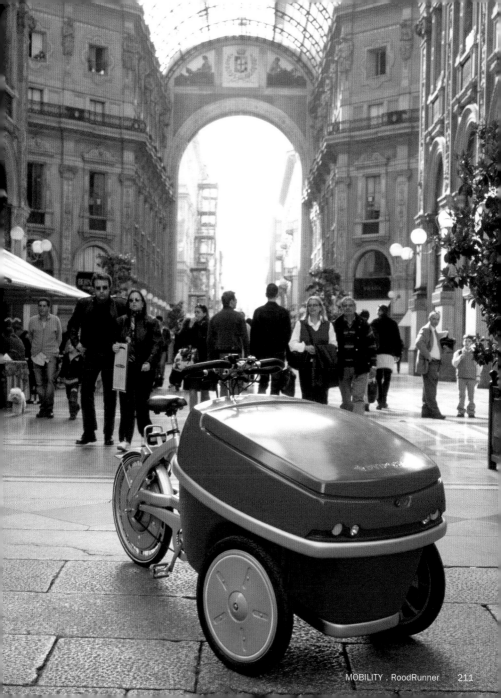

Tesla Roadster

Designer: Tesla Motors
Manufacturer: Tesla Motors, www.teslamotors.com

This car has everything that can be expected of a sports car—with the distinction that it is powered by an electric motor. The manufacturer promises rapid acceleration and a range of over 220 miles.

Bei diesem Auto ist alles so, wie man es von einem Sportwagen erwartet – mit dem Unterschied, dass es von einem Elektromotor angetrieben wird. Der Hersteller verspricht eine rasante Beschleunigung und eine Reichweite von über 350 km.

Cette voiture possède tout ce qu'on peut attendre d'une voiture de sports – à la différence qu'elle est propulsée par un moteur électrique. Le fabricant promet une accélération rapide et une autonomie allant jusqu'à 350 km.

Este coche dispone de todo aquello que se espera encontrar en un deportivo, con la diferencia de que su propulsor es un motor eléctrico. El fabricante asegura que su aceleración es vertiginosa y que su autonomía se queda muy cerca de los 350 km.

Questa macchina ha tutto quello che ci si aspetta da un'auto sportiva – con la differenza che viene azionata da un motore elettrico. Il produttore promette un'accelerazione rapidissima e un'autonomia di circa 350 km.

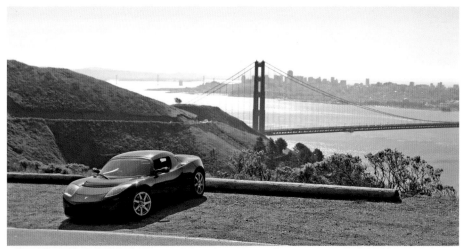

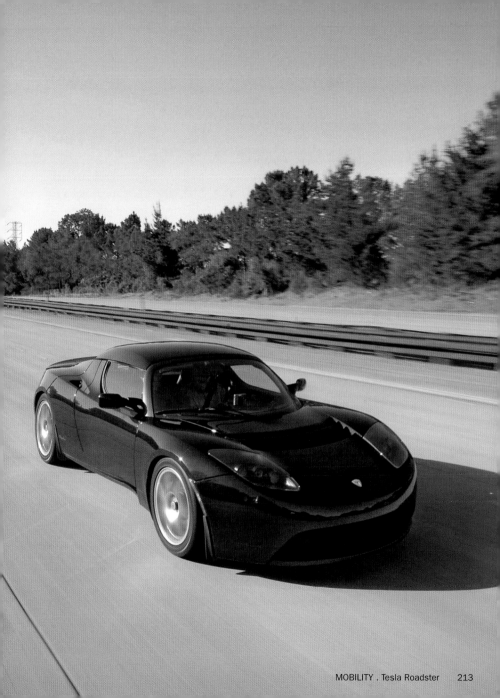

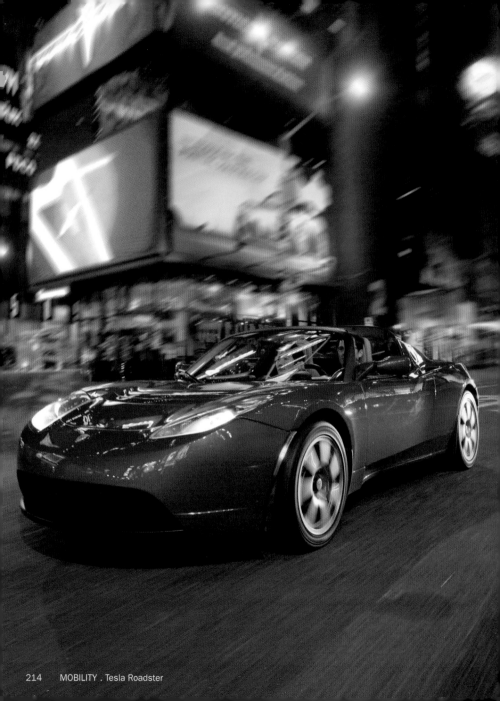

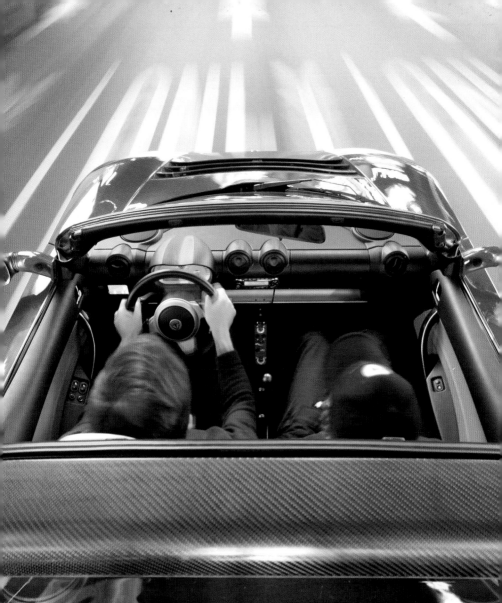

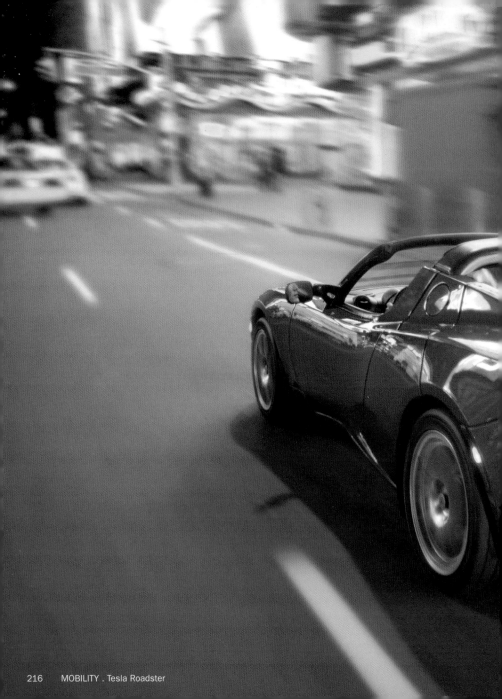

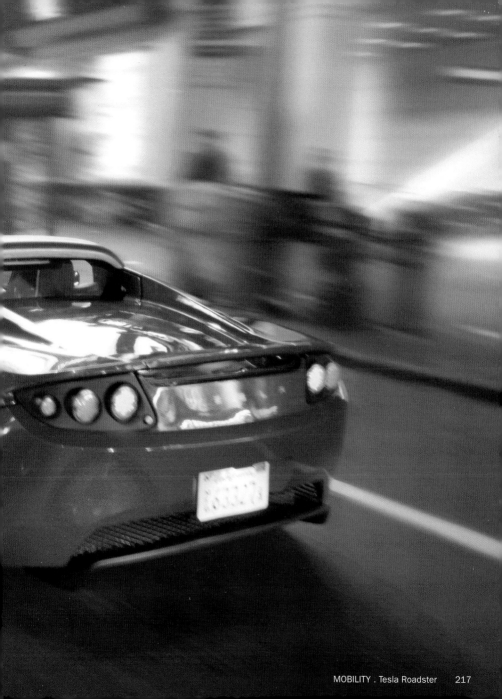

VERDIER Solar Power

Designer: Alexandre Verdier
Manufacturer: Verdier, www.verdier.ca

Like its predecessor in the 1960s, this Westfalia Van is designed to transport both the passengers and an independent attitude toward life. The hybrid vehicle is equipped with a large solar panel and also offers all types of additional equipment such as a computer with an energy-consumption display.

Wie sein Urahn in den 1960ern soll dieser Westfalia-Van außer den Insassen auch ein unabhängiges Lebensgefühl transportieren. Das Hybridfahrzeug ist mit einem großen Solar-Panel ausgerüstet und bietet noch allerlei Zusatz-Equipment, z.B. einen Computer mit Energieverbrauchsanzeige.

Comme son prédécesseur des années 60, le Van Westfalia est conçu pour transporter des passagers tout en affirmant une philosophie de vie indépendante. Ce véhicule hybride est équipé d'un grand panneau solaire et offre toutes sortes d'équipements supplémentaires comme un ordinateur avec affichage de la consommation d'énergie.

Al igual que su antecesora de la década de los 60, esta furgoneta Westfalia, además de transportar a sus ocupantes, también irradia una sensación de independencia. Este vehículo híbrido está dotado de un gran panel solar y de infinidad de equipamiento extra, como por ejemplo un ordenador con indicador de consumo energético.

Come il suo antenato negli anni '60 anche questo camper Westfalia deve trasmettere una gioia di vivere indipendente, e non solo a chi lo occupa. Questo veicolo ibrido è dotato di un grande pannello solare e offre numerosi accessori aggiuntivi, come per esempio il computer con l'indicazione dell'energia utilizzata.

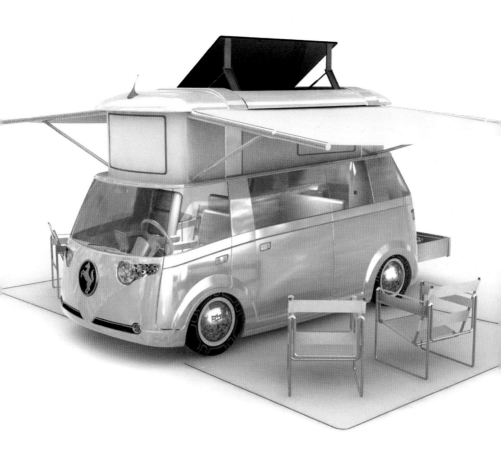

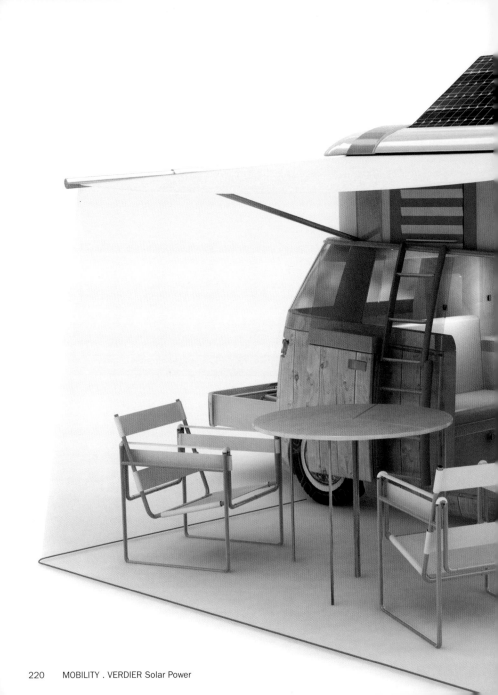

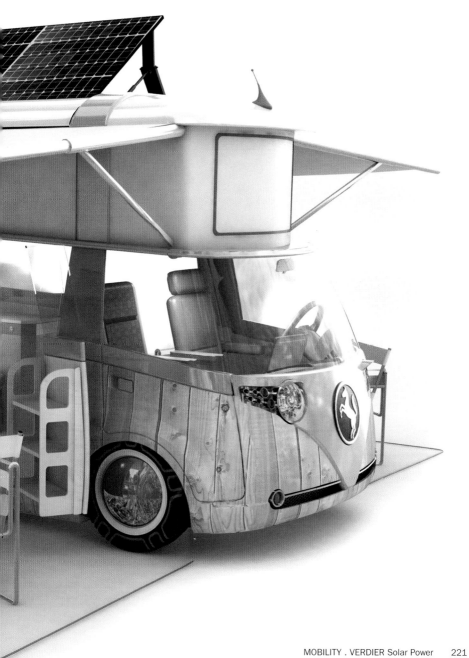

ZEUS – Zero Emission Urban Scooter

Designer: Michiel Knoppert, Marcel Schreuder
Manufacturer: Springtime, www.springtime.nl

The goal of this concept study was developing an individual design language for the urban scooter with electric drive. Many details of the previous motor scooters have been revised and given a new concept: For example, the battery can simply be taken home for charging.

Eine eigene Formsprache für urbane Roller mit Elektroantrieb zu entwickeln war das Ziel dieser Konzeptstudie. Viele Details bisheriger Motorroller wurden überarbeitet und neu konzipiert: Die Batterie etwa lässt sich zum Aufladen einfach mit in die Wohnung nehmen.

Le but de ce concept était de développer un langage de design particulier pour le scooter électrique. De nombreuses caractéristiques des scooters à moteur précédents ont été revues et corrigées : par exemple, la batterie peut tout simplement être rapportée à la maison pour être rechargée.

Crear un propio lenguaje formal para un scooter con propulsión eléctrica fue el objetivo perseguido con este prototipo. Se retocaron muchos detalles de los actuales scooters, y algunos son de nueva concepción, como por ejemplo desmontar la batería y llevarla a casa para recargarla.

Lo scopo di questo studio di concetto era quello di sviluppare un linguaggio formale proprio per lo scooter urbano elettrico. Molti dettagli dei motorini fino ad ora utilizzati sono stati rielaborati e concepiti in forma nuova: la batteria per esempio si può semplicemente portare nell'appartamento per essere caricata.

Other titles published in this series

Cool Hotels London
ISBN 978-3-8327-9206-0

Cool Hotels New York
ISBN 978-3-8327-9207-7

Cool Hotels Paris
ISBN 978-3-8327-9205-3

Cool Hotels Italy
ISBN 978-3-8327-9234-3

Cool Hotels Spain
ISBN 978-3-8327-9230-5

Cool Hotels Spa & Wellness
ISBN 978-3-8327-9243-5

Ecological Design
ISBN 978-3-8327-9229-9

Ecological Houses
ISBN 978-3-8327-9227-5

Garden Design
ISBN 978-3-8327-9228-2

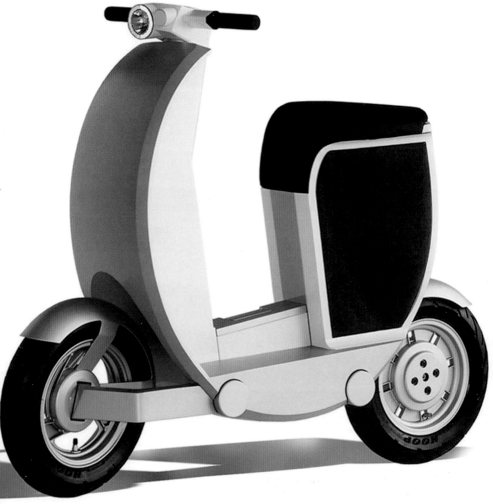